PARANORMAL
SOUTH TYNESIDE

MICHAEL J. HALLOWELL

AMBERLEY

Dedicated to the Memory of Martin Embleton, a gentleman of South Shields whom I think knew far more about this strange world in which we live than anyone ever imagined.

A small number of experients mentioned in this book have requested anonymity, and their real names have been replaced with fictitious pseudonyms which are denoted with an asterisk thus* the first time they are used.

First published 2009

Amberley Publishing
Cirencester Road, Chalford,
Stroud, Gloucestershire, GL6 8PE

www.amberley-books.com

British Library Cataloguing in Publication Data.
A catalogue record for this book is available from the British Library.

ISBN 978 1 84868 730 1

Typesetting and origination by Amberley Publishing
Printed in Great Britain

CONTENTS

ACKNOWLEDGEMENTS

Alan Tedder, friend and researcher, for allowing me access to his personal archives. Without his assistance, several stories in this volume would not have appeared in print. Darren W. Ritson, my dear friend and colleague, for his unstinting support over the years and for writing the Foreword to this book.

The following correspondents, amongst others, who were happy to share their stories with me:

Alan, Andra, W, Arnold Marsh, Colin, David Keedy, Dorothy Haygarth, Dot Golightly, Elaine Switt-Edwards, Idora Clarke, J, Janice White, Jeanne Stewart, Keith Wallace, the late Martin Embleton, Mike Byrne, Michelle, Mrs M, Peggy Smith, Phil Toomey, Susan, Tom Jadz, Tracey McGarvie.

All images in this book are courtesy of Thunderbird Craft & Media.

FOREWORD

To be asked to pen a Foreword for a book on paranormal phenomena by an expert researcher such as Michael Hallowell really is an honour. But before we venture any further, let us look at the term 'paranormal researcher'. 'Paranormal researcher' is an expression that is used way too frivolously these days and, to be quite frank, by those who are not actually paranormal researchers. Most ghost hunters are usually guilty of this and, if I'm honest, I've been guilty of it myself – but I try to learn from my mistakes, and so should others. You see, ghost hunting is just *one* small aspect of the world we call 'the paranormal'.

To be a paranormal investigator in the true sense of the word, you need to investigate all (or most) aspects of it and Mike Hallowell does this on a day-to-day basis. UFOs, mystery animals, premonitions, ghosts, 'invisible' childhood friends, telepathy and ESP are just some aspects which he studies with much enthusiasm, and many of them are featured in this book. He has done an impressive job, as you will soon see. In all my years of ghost hunting and writing, I have rarely come across researchers who could be truly considered *bona-fide* paranormal investigators, but Mike is one of them.

I first met Mike back in early 2003 when we were both part of a local ghost research society. I remember the day we met for the first time when he ambled into Newcastle Keep one Saturday afternoon with his bag over his shoulder. He had been away carrying out his paranormal 'business' in the form of a lecture on poltergeists. In fact, he had been invited to speak at a meeting by a correspondent of mine called Malcolm Robinson. Malcolm had kept me on the straight and narrow in my early days of investigating ghosts and UFOs and Mike knew him well – it's a small world. We were subsequently introduced and from that point on I knew I had met someone with more enthusiasm for paranormal phenomena than anyone else.

Mike researches and writes up stories of the paranormal with the intent of giving the reader something to really enjoy. His work is entertaining and something that we can all take great pleasure in. More to the point, his research is practical, well researched and truthful. His methodical approach to his work is second to none, leaving no stone unturned when it comes to researching Fortean phenomena, and those who read his 'WraithScape' column in a local newspaper will be in no doubt of this.

When I became involved with the now-infamous South Shields poltergeist case in 2006, I needed a co-investigator to assist in the research and documentation of the investigation, a professional investigator with honesty, diplomacy and above all, knowledge – there was no one else. I asked Mike if he would accompany me to the house in question and he obliged. From that day on our lives changed in a way we could never have dreamt and we haven't looked back since.

There are ways and means to investigate paranormal phenomena, and Mike knows this only too well. He is not prone to fancy flights of imagination and reports his findings in an honest and reliable way. A lot of other researchers could learn from Mike and his methods, as I have, and it has been a great pleasure to work with him.

The borough of South Tyneside is awash with creepy tales, folkloric legend, UFOs and ghosts of long gone days. I should know: I have personally investigated many of them. Indeed, South Tyneside seems to be a paranormal hotspot for poltergeist activity with at least half a dozen cases that we know about, one, of course, being the much publicised and aforementioned South Shields poltergeist. Mike has done us proud and has prepared a first-rate compendium of the wacky world of South Tyneside with some of the most unorthodox cases you will probably ever read about.

Anyone who knows me will acknowledge the fact that I am brutal with my honesty – you have to be, despite the repercussions it may have. Indeed, I have lost so-called friends through 'trying to do the right thing' but, in retrospect, this is a small cross that I can most certainly bear. Every word I say about the author of this work is sincere and comes from the heart – that I promise you.

Paranormal South Tyneside is a wonderful book full of paranormal peculiarities and it deserves the widest possible readership. I thoroughly enjoyed reading it and I am sure you will too.

Darren W. Ritson, 2009.

INTRODUCTION

For years now I have penned a weekly column for a local newspaper on paranormal phenomena. The column acts as a clearing-house for strange tales, eerie stories and peculiar parables of all kinds. It is, as one colleague of mine cheekily described it, 'the Grand Central Station of the unknown and the mysterious'.

Writing about the paranormal is a labour of love. Readers send me scores of stories and experiences, each one a wonderful vignette which allows both I and the column's fans a peek into a strange, disturbing world. You may call it the Beyond, the Spirit World, the Fourth Dimension or whatever you will, but here, in this environment of mists and shadows, nothing is quite what it seems to be and – worse – everything is unsettlingly different to the way it should be. This is a twilight landscape inhabited by ghosts, wraiths, spirits, aliens, bizarre creatures and entities of even stranger ilk.

The north of England is a very mysterious place. Phantom aircraft whisk through its darkling skies, engaging in mysterious journeys to who-knows-where from lord-knows-when. Whilst exotic sea-monsters frequent its turbulent oceans, in its gnarled and shadowy woods you may stumble upon the legendary Beast of Bolam Lake or, if you're really lucky (or perhaps unlucky), the infamous Cleadon Panther. In this twilight world, nothing can be taken for granted. Indeed, those who enter do so at their own risk.

In the caves and cliffs of this beautiful region even darker creatures dwell, like faeries and 'wee folk', often not as benign as they are made out to be in story books.

In my quest to solve mysteries I have travelled extensively. I've investigated UFOs over Amsterdam, ghouls in Memphis, lake monsters in Geneva, serial killers in Jarrow, ghosts in Grimsby and graveyard dogs in Galveston. I take part in TV documentaries and radio 'phone-ins on the 'unexplained' from far and wide, but, at the end of the day, the north-east of England, and South Tyneside in particular, will always be my biggest love when it comes to the strange, mysterious and sometimes downright scary. As you will see from the contents of this book, it must be a prime candidate for the UK's spookiest borough – bar none.

For months now I have been trawling through my neatly catalogued files, extracting many of the strange stories I have investigated over the years. They have been reworked, expanded and updated for this volume and also interspersed with other eerie tales that have never before appeared in print. My endeavour has been to make *Paranormal South Tyneside* a delicious smorgasbord of truly paranormal stories. Somehow, I don't think you'll be disappointed.

Mike Hallowell

CHAPTER 1

ANGELS

Several years ago, I happened to be walking down Fowler Street in South Shields during my lunch hour. Scaffolding and tarpaulins had been erected next to several buildings where some maintenance work was being carried out, and one or two workers wearing hard hats were scurrying about with buckets full of cement and planks of wood.

I was about 6ft away from the scaffolding, which protruded right across the pavement, and was just about to walk underneath it on the designated walkway. But something stopped me. Suddenly, I had an overwhelming compulsion *not* to walk underneath the scaffolding. Instead, I walked across the road and turned into Keppel Street on the outside corner by McDonalds.

Some people would say that my actions were completely irrational. All I can say in my defence is that I had an overpowering feeling that something terrible would happen if I continued to walk under the scaffolding. As it happens, nothing did happen. No chunks of masonry hit the ground where I would have been walking and several other pedestrians passed under the scaffolding safely. But to this day I cannot help but feel that something would indeed have happened had I ignored that inner prompting.

What causes such spontaneous 'warnings' to invade our consciousness? Well, theories abound. Psychologists say there is nothing paranormal going on at all. What happens is

Fowler Street in South Shields, where the author had a premonition that something bad might be about to occur.

that our senses may pick up subliminal or 'hidden' danger signs, and although we are not consciously aware of them they prompt us to take evasive action. Well, maybe, but then again I might have an angel sitting – metaphorically, if not literally – on my shoulder.

PSYCHICALLY DETECTING A BURGLAR

Some time ago I was told the story of a woman who came home from work and entered her flat. As soon as she entered the hallway she 'sensed' that someone was in the flat with her. Quietly, she left by the same entrance, locked the door and telephoned the police from her neighbour's home. A patrol car sped to the scene and the man was arrested trying to climb out of a window.

Later, the lady in question was placed under hypnosis and asked exactly what had 'told' her that she was not alone in her home. Whilst in a trance she managed to recall what she had been unable to remember when fully conscious. In fact, on entering the flat she had become subconsciously aware of the burglar's body odour.

But not all warnings can be dismissed in such scientific terms. My files contain accounts of several people who have received psychic prompts not to board a certain aircraft, only to be told later that the flight in question had crashed. Surely, it is stretching things to the limit to suggest that a person can remotely detect faulty circuitry in an aircraft cockpit by any conventional means. Rationally, we would have to admit that something else must be involved.

In the Biblical book of Isaiah, God tells the Israelites, 'And your ears shall hear a word behind you, saying, "This is the way, walk in it", when you turn to the left and when you turn to the right.' (Isaiah 30;21). Guiding voices in the ear are, it seems, quite an ancient phenomenon. This observation has led more than one researcher to link the occurrence of 'inner prompting' with that of another fascinating topic, that of guardian angels.

Could it be that we each have a guardian angel to warn us when disaster is about to strike? For thousands of years this belief has permeated some of the world's most ancient and influential faiths, including Judaism, Christianity and Islam.

THE HEALTH VISITOR GUIDED BY AN ANGEL

Health Visitor Idora Clarke was driving through Hebburn one evening when, without any warning, her foot applied the brake. Idora was bemused, because she had not intended to brake at all. Suddenly, a young boy on a skateboard shot onto the road ahead of her.

'He went onto the road just about where my car would have been had I not braked', she told me. 'The thing is, I couldn't have seen him. He was only little and he was hidden by a brick wall until just before he hit the road.'

Idora is convinced that her guardian angel made her brake to avoid hitting that young boy; what cannot be disputed is that something made her stop.

There is a very old tradition that guardian angels can sometimes take on the appearance of the person they are protecting. Interestingly, we can again turn to the Bible for confirmation of this. The Book of Acts (9; 12-17) describes how the Apostle Peter was imprisoned by King Herod. In the middle of the night, Peter's guardian angel miraculously removes his chains and frees him from the prison. Peter then journeys to the house of Mary, mother of John

Health Visitor Idora Clarke claims that an angel prevented her from knocking over a boy on a skateboard who dashed out in front of her car. (Artistic representation)

Mark. When Peter arrives, the door is answered by a young girl called Rhoda. When Rhoda goes back inside and announces that Peter has come to visit, the entire household tells her that she must have flipped her lid. How could Peter possibly be standing at the door when everyone knew he was safely banged up in the Palestinian equivalent of Alcatraz?

Not to be put off, Rhoda sticks to her guns and tells her friends that they can think what they like but it won't alter the fact that Peter is standing at the door. Still not convinced, they then declare, 'It must be his angel'. The rest of the story is quite gripping, actually, and well worth the read. Nevertheless, the point is that they obviously believed that Peter's guardian angel was identical in appearance to Peter himself.

Sticking with the Biblical theme, the writer of the Book of Hebrews – and we can't be sure exactly who that was – warns us always to be hospitable to strangers, 'for in this manner some have entertained angels *unawares*' (13;2). This is an extremely sobering thought. The next time you're sharing a cup of tea and a jam doughnut with a friend, you may actually be chatting with their (or your) guardian angel! Seriously though, the idea that we each possess a divine messenger who watches over us is comforting. If we listen carefully, perhaps we can hear them whispering.

Wartime is always accompanied by strange tales: the phantom bowmen, who allegedly helped the English during several of our spats with the French; the Angels of Mons, who allegedly appeared in the sky to British troops during the First World War as they retreated, supposedly holding the German forces back; and so on.

Are such experiences grounded in reality? Or could they be the results of humans being subjected to intolerable amounts of stress? Actually, both are possibilities. During warfare both soldiers and civilians are placed in danger. Unless one has experienced the death and carnage first hand, the imagination can but poorly compensate. Living in constant fear for your life from day to day also notches up the pressure. Under such circumstances, the human mind can be forgiven for acting irrationally. Over half of the widows I once interviewed for a feature claimed to have experienced visual or auditory hallucinations which looked/sounded like their dead spouse. These are known as grief

apparitions and are caused by the terrible stress of losing a loved one. Of course, if deeply unhappy people can imagine they've seen the ghost of a loved one then it's not beyond the bounds of possibility that they could imagine angels, too.

'I'LL BE WITH YOU ALWAYS'

I once received a letter from Janice White of South Shields, an elderly retired nurse who lost her husband to cancer some years ago. On the night he died, Robert told Janice that he would always be with her. His prediction was soon to be fulfilled in a most remarkable way. Two hours before he finally passed away, Janice went to the hospital canteen for a cup of tea and was astonished to see Robert, apparently hale and hearty, standing in the queue at the checkout. He turned, looked at her and said something she didn't quite catch. Then, in a heartbeat, he was gone. Janice returned to the ward and sat with Robert till he died. Later, as she left the hospital, she again saw her husband standing in the foyer. As before, he smiled at her and then disappeared. Had Janice really seen the ghost of her husband in the form of an angel? If so, then we are forced to conclude that ghosts can be representations of the living as well as of the dead, for at his first appearance in the cafeteria Robert was not yet deceased. Then again, perhaps Janice was merely imagining she could see Robert due to the extreme stress she was experiencing. It should not be surprising to find, then, that soldiers in the heat of battle often suffer from such stress-induced experiences.

But they can't all be explained away so easily. Take the aforementioned Angels of Mons, for example. When the British troops were retreating from Mons, in Belgium, in the face of a strong German advance, reports came in from dozens of soldiers who claimed that angels could be seen hovering over the German forces. With outstretched arms (and, one presumes, wings) these angelic creatures allegedly held back 'the Hun' until the British were well clear. Newspapers on this side of the Channel were full of it, of course, for it supposedly proved that God was on our side and not theirs.

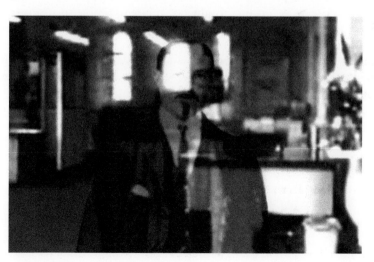

Janice White's husband appeared to her twice in a local hospital – once before he died. (Artistic representation)

Now, it would be easy to dismiss such a tale as rubbish but the fact is that both the number and quality of the witnesses makes this impossible. Furthermore, some German soldiers later claimed that they had witnessed angels in the sky at precisely the same moment. Something strange must have happened, and such things are not solely within the province of past centuries.

LIFTED FROM DANGER BY AN ANGEL

I once met an ex-soldier from South Shields who had served in Northern Ireland. For security reasons he was unable to furnish me with precise details regarding his tours of duty in the Emerald Isle, but he did tell me of an uncanny experience which occurred when he was on duty in the war-torn province. I wrote the story up in my 'WraithScape' column shortly afterwards.

> My task was to observe a certain street, so I was using a derelict building to hide in. Whether it was laziness or bad soldering I don't know, but I had used this building several times, so the terrorists must have seen me and decided to plant an explosive device there, enabling them to detonate it the next time I used it.
>
> Well, their plans worked well as the device went off. However, I believe that God had plans of his own for me. Before the explosion I felt two hands take me and lift me out of the open window on the upper floor and place me on the pavement a safe distance away. At first I wrote this off as a strange effect of the blast. It was not until several years later when, during a Bible study, someone read a description of an angel. It especially mentioned the hands, and then it dawned on me that the hands that lifted me to safety fitted their description perfectly.

Guided by an angel? Readers must decide for themselves, but it does seem strange that he suffered no injuries and that he remembers being lifted to safety before the bomb exploded.

Did an angel lift a soldier to safety seconds before a bomb exploded? (Artistic representation)

12

CHAPTER 2

ANIMAL ANOMALIES

Some years ago, a reader wrote me an interesting letter. What she wanted to know was whether pet animals can communicate from 'the other side'. Sceptical? Well, read the following tale before you rush to judge.

BRUNO'S BACK

Mrs M. is a busy mum who has been blessed with three beautiful children. Until recently she also had a dog called Bruno who was adored by the whole family. Sadly, Bruno died one April, and everyone in the household was devastated.

Some time after Bruno's passing, Mrs M. happened to be watching the popular *Psychic Livetime* programme on the Granada Breeze satellite channel. The resident medium on the programme was the renowned Derek Acorah, whom I first met whilst appearing on *Psychic Livetime* myself.

Mrs M. remembered Derek saying that one of the easiest ways for a spirit to demonstrate its presence is by tipping over a photograph of his or herself. On a hunch she tried this with a photograph of Bruno, but nothing happened. Time passed, and Mrs

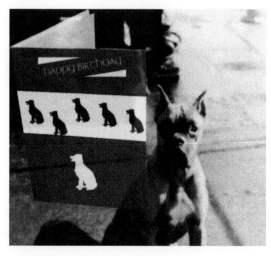

Bruno the dog made his presence felt – after his death and on his birthday.

M.'s children – triplets – celebrated their birthday some months later. By coincidence, it would have been old Bruno's birthday the day after. The family always bought Bruno a card on his birthday for, as Mrs M. said in her letter, he was really 'one of the family'.

Mrs M. mentioned to her husband how sad it was that there was no card for Bruno standing on the hearth next to the cards there for the children. At that very moment, without any rational reason, a large birthday card fell over on to its side. It seems to have been the timing of the thing that startled the couple. 'We nearly passed over to the other side with fright', said Mrs M.

Of course, even Mrs M. admits that it could have been coincidence. But was it? Or was their beloved Bruno just letting them know that he was still around? Personally, I don't think it matters, for Bruno very much exists in the hearts and minds of the family he once was a part of.

ANIMAL SIXTH SENSE

Some years ago, I was asked by some amateur investigators to accompany them to a haunted house in Baring Street, South Shields. There was an interesting feature of this case that attracted my attention: two dogs residing in the property were just as able to sense that something strange was going on as their human companions. Animals, you see, are often more sensitive to paranormal phenomena than humans.

The eyes of dogs and cats are structured differently to those of people and some researchers believe that this enables them to see apparitions that are invisible to human witnesses. I would venture that just about every dog or cat owner has at some time watched incredulously as their pet has jumped up and apparently followed a seemingly invisible presence across the room with their eyes. This was certainly the case in the investigation mentioned above.

Before we move on, I'd like to relate to you a personal experience with psychic animals, which I know many pet owners will relate to. Years ago, my paternal grandparents had a cat called Spaggs. It was, as I recall, predominantly black, with white patches. Spaggs had character. He would certainly have won – hands down – the Ugliest Cat in the Universe competition and he carried proudly the scars of many a battle. He was a veteran cat, an old cat, a wise cat and a warrior cat.

Spaggs had a favourite resting-place, which was behind the TV set in the living room. No one knew why and no one dared question him. Spaggs had a way of looking at you. If you wanted to find Spaggs, he would be either patrolling the streets in search of The Enemy or snoozing behind the TV. In his twilight years it was generally the latter. Until six o'clock, that is. For then, like clockwork, he would rise and take a brisk walk to Jarrow train station to meet my grandfather as he returned from work. As South Tynesiders know, Jarrow station – now part of the Metro system – lies on the main Newcastle to South Shields line.

Everyone used to laugh at Spaggs. How on earth was he able to tell the time? The general consensus was that it was some kind of 'animal instinct'. Whatever, it was a source of amusement. Come six o'clock, we just knew that Spaggs would get up and walk to the station.

But there's more to this story. Occasionally, my grandfather's train would be late. Or he'd have to work overtime. On such occasions Spaggs would continue to doze quietly behind

The author's paternal grandparents with Spaggs the psychic cat.
The photograph was taken in 1963, six years before Spaggs died.

the TV until it was time for the later train to arrive. Then, Spaggs would get up and go to the station to meet it. Spaggs not only knew what time the train was due to arrive, but he also knew whether or not my grandfather would be on it. This is not good timing but extra-sensory perception (ESP) and many animals possess it to an extraordinary degree.

In 1978 June Hartow of Tuscaloosa, Alabama, noticed that her pet Spaniel, Gubboy, was acting strangely. At 6.30pm it became very restless and started pacing up and down the hallway, whimpering and whining. June tried pacifying the dog by offering it biscuits but it refused them.

On a whim, June opened the door at the rear of the house and was amazed to see Gubboy race across the garden and jump over a high fence. June unlocked the gate and followed the dog to a small workshop where her husband worked two blocks away. When she arrived, Gubboy immediately ran to the office at the rear of the workshop where June's husband was lying unconscious. June phoned for an ambulance and he was rushed to a nearby hospital. Tests later revealed that he had suffered a heart attack, from which he fortunately made a full recovery. The question is, what would have happened had Gubboy not sensed that something was wrong and led June Hartow to her husband?

Orthodox scientists vehemently deny that animals possess psychic abilities, but a small number of studies seem to bear out the claims of many owners that their pets do indeed have an uncanny 'sixth sense' which can warn that danger is ahead.

But we don't need to travel to Alabama to find psychic pets – they reside in South Shields in abundance. Pigeons are also believed to possess psychic talents. A pigeon fancier from South Shields told me, 'people think I'm daft as a brush, but I'm telling you, those birds can read your mind. Sometimes they just look at you, and you know that they can sense what you're thinking.' He continued, 'when my wife died I went to feed the pigeons, and they were just standing in semi-circle looking at me. They knew – and *I* knew that *they* knew'.

Even more extraordinary is the ability of some pigeons to 'home in' on other family members. In June 1995 a female Bushart cross was released from Beau Vois, France. The

game plan was for the bird to fly back to Northumberland, but our feathered friend had other ideas and promptly headed off for the more exotic clime of Casablanca.

Several months later, the first bird's nephew – barely out of nappies – decided that he'd had enough of the English weather as well and went off to join his auntie in her new loft on the Moroccan coast. (How he knew where to find her has not been satisfactorily explained. Maybe she sent him a postcard.) Seriously though, it is extremely difficult to explain away such events in conventional, rational terms.

Cats are renowned not just for their ability to know when things are about to happen but also for their ability to 'see' things not apparent to their human owners. Many cat owners will testify that Tiddles, Winky or Marmalade has, at one time or another, appeared to follow an invisible person with their eyes. Suddenly they will look up and gaze at something apparently traversing the room. The problem is that humans present may not be able to see exactly what or who that something is!

Feline eyes are structured differently to human ones, and it is widely believed that cats may have the ability to see things that we can't. Dogs, too, will sometimes stare fixedly at a particular place and growl menacingly. Perhaps this has something to do with the fact that canines are able to hear sounds inaudible to the human ear.

Whatever the explanation, it can't be denied that animals are acutely sensitive in ways that we humans are not. Even the most sceptical scientists accept that just before an earthquake, birds, dogs, cats, horses and other animals often begin to act in a bizarre fashion, making strange noises and migrating from their normal habitat. It has recently been suggested that a national reporting centre should be set up where owners can report such changes in behaviour, the idea being that if a good number of calls are received the emergency services can be notified that an earthquake may be on the way.

The world we live in moves at a hectic pace. People have little time to devote to more spiritual matters and for this reason we often feel very uneasy when the invisible world beyond our senses invades our own. Animals can also become afraid in similar circumstances. Once, in the middle of the night, I saw a Rottweiller growl ferociously as it gaped up a stairwell in the Marsden Grotto. I looked up the stairwell and could see nothing. After a while the dog retreated down the stairway, still growling and staring intently towards the top. I went up the stairs to the room above, only to find it perfectly empty. The dog? It definitely saw something that was invisible to me, and whatever it was it didn't like it.

PANTRY PANDEMONIUM

'WraithScape' reader Peggy Smith sent me the following story via e-mail:

> I live in an old house which has a small pantry just off the kitchen. I've often had the feeling that there is something funny about it but it's hard to say what. My cat Sherman won't go in the pantry. Sometimes he'll stand at the door when I'm in there, as if watching out for me.
>
> Last week I went in the pantry to get something, and when I came out I left the door open. The next thing I knew, Sherman was screeching like something wasn't right. He was standing on his back two legs and clawing at something at the pantry doorway. Whatever is in the pantry never bothered me before, but after the way the cat reacted I'm not sure any more. Maybe it's something evil.

Peggy Smith's cat, Sherman, regularly detected a ghostly presence in her pantry cupboard. (Artistic representation)

Personally I don't think Peggy has anything to worry about here, and whatever is haunting her pantry I don't think it's anything malign. Animals can be just as subject to irrational fears as humans. Peggy is now assuming that her own cat, Sherman, was attacking this invisible presence because it is evil or harmful. In fact, the cat was probably acting aggressively because it sees the presence as an interloper or intruder. My bet is that the apparition may actually be that of another cat – a cat which lived (and probably died) in the house years ago. This spectral cat isn't bad – it's just encroaching on Sherman's territory!

Reader Jimmy Purcell*, whose story also appeared in my column, still sees the spectre of his own cat wondering around his flat, even though Tibbs died years ago. 'I see him sleeping in the corner he always slept in, sunning himself under his favourite window and, occasionally, scratching at the corner of the sofa.'

WANDERING WILLIE

Relatively few people in South Tyneside will now be able to recall who Wandering Willie was, and, certainly, no one alive today ever saw him. Wandering Willie was a bit of a character in South Shields, but he died well over one hundred years ago. For those who don't know the story, I'll be happy to introduce you to it.

In the summer of 1873, so the story goes, a shepherd from the Cheviots was tasked with taking a large flock of sheep to the Cleveland Hills. Nowadays, of course, they'd be transported by road in proper containers, but things were different then. In those days you had to walk, and the Cleveland Hills were one helluva long way away.

The shepherd was accompanied by a dog, whose sole purpose was to herd the sheep, and one morning the shepherd, the dog and their woolly charges arrived at the ferry landing at North Shields. They caught the ferry across to the other side of the River

Wandering Willie, the strange dog which roamed South Shields in the nineteenth century, is now preserved and on display in a public house.

Tyne – sheep were welcome on the ferry then – and within quarter of an hour they were gambolling up the South Shields landing towards Market Square. Just as they passed a pub called the Alum Ale House, disaster struck. Something startled the sheep and they all ran off in a multitude of different directions. Before the shepherd could do anything to rectify the situation, they had all disappeared. The nearby streets, however, were filled with dozens of woolly interlopers.

Quite naturally, the shepherd had a rescue plan for this sort of situation, and the dog, Willie, was dispatched to round them up, but his task seemed hopeless. Nevertheless, over the course of several hours he managed to return the sheep to the ferry landing. The shepherd quickly counted and was alarmed to find that one sheep still seemed to be missing. The dog was immediately sent off to look for it.

An hour or two passed and neither dog nor sheep had returned. The shepherd, puzzled, did another head count and discovered that no sheep were missing at all – he'd simply counted wrongly the first time. Night was drawing in and the shepherd wanted to be on his way before dark. Reluctantly he took up his journey in the belief that Willie would follow on when he eventually returned.

Well, things didn't work out as planned. The dog was puzzled at his master's absence and decided to wait by the ferry landing for his return. For several months he waited faithfully, surviving on scraps fed to him by kindly passers-by. Some took him home, but the dog – now named 'Wandering Willie' by locals – would immediately decamp and return to the last place he saw the old drover.

Before long Willie became a celebrity and, according to contemporary accounts, he actually got a bit above himself. For a while he associated with a gang of local ruffians and engaged in all manner of mischief, particularly at the ferry landing and at the well-known crossways called Comical Corner. So irritating did his behaviour become that he was permanently banned from the ferry, which he really liked to travel upon. Willie's reputation went down the pan in a very short space of time.

For no less than fifteen years Wandering Willie lived by the ferry landing, but eventually his eyesight dimmed and arthritis started to eat away at his bones due to constant exposure to the elements. He became incapable of looking after himself, but, mercifully, a retired ferryman took him in and cared for him until he passed away in the autumn of 1890. The legend of Wandering Willie lived on, however, and youngsters from all over the borough were told stirring tales of his adventures.

At the time a local paper lamented that, 'It is sad to know that he went to his grave without ever again looking upon the face he loved so well'. It's true. Wandering Willie never did see the old shepherd again, but it seems that he at least lived out the last years of his life with a degree of happiness and, latterly, comfort. Wandering Willie was really South Shields' equivalent of Black Bob the 'Wonder Dog' featured in the *Dandy* comic many years ago, and the town was the less for his passing.

In the winter of 2007 I related to readers of my 'WraithScape' column the amazing tale of Wandering Willie and asked that if anyone had any further details about the canine wonder I'd love to hear them. As over 120 years had passed since the legend of Wandering Willie had drawn to a close, I doubted that anyone would recall the story. I was wrong. 'WraithScape' reader Martin Embleton from South Shields contacted me to tell me that his father actually knew Wandering Willie as a child.

Martin was a retired marine engineer. A sprightly eighty-eight year old, he also sang with his wife Norah, and their efforts were recorded onto a CD entitled *The Fantastic Sound of Martin & Norah Embleton.*

Martin's father, also a marine engineer, was Joseph William Embleton. Coincidentally, Joseph was born in the same year that Wandering Willie first arrived in South Shields and was quite familiar with him during his childhood. Martin was born in 1919, and when he was eight his father began to relate to him the exploits of Wandering Willie and his daring adventures.

'It's true that Willie got into some scrapes', Martin told me, 'but he wasn't a bad dog. It was the youngsters he fell in with. He was well loved both in North Shields and South Shields, and that's how he got his name, Wandering Willie. He continually went between North Shields and South Shields on the ferry, wandering between the two towns.'

William Embleton had lived in Alice Street and told his son of how he would regularly see Wandering Willie by the ferry landing, still waiting for his master to return. What happened to Wandering Willie after he died was something of a mystery, although Martin told me he thought he had the answer: 'according to my father, who died in 1961, Willie's body was stuffed and mounted in a presentation case. Before he passed away he told me that it was still on display in a pub in North Shields, but I don't know which one.'

Well, I decided to try and find out. Once again I put an appeal in my 'WraithScape' column and asked if readers out there knew of Willie's whereabouts, please get in touch. Martin told me he would like to see a monument to Wandering Willie placed by the ferry landing: 'I think a plaque would be nice, bearing the true tale of Wandering Willie. It would be good for local people to read who don't know about it, and for tourists.' I agreed, but added that I'd personally like to see a full statue, which would be a real landmark.

Martin continued with his detective work and, along with another reader, managed to track down the preserved remains of Wandering Willie to a pub in North Tyneside called the Turk's Head. One day, my wife Jackie and I, along with our daughter-in-law Rachel, went over to the pub to see Wandering Willie. His remains had been expertly preserved by a taxidermist and to this day lie in an ornate display case set into the wall of the lounge.

Martin Embleton, who helped the author solve
the mystery of Wandering Willie.

In 2008, I wrote up the story of Wandering Willie in my book, *Mystery Animals of
the British Isles; Northumberland & Tyneside* but there was yet to be a sad and final
chapter to my involvement with the Wandering Willie saga.

The truth is that if it hadn't been for the help I received from Martin Embleton I would
never have been able to finalise my research into the story. When Jackie and I first went to
visit Martin, he turned out to be a delightful gentleman whose kindness and enthusiasm
were boundless, despite his advancing years. Sadly, I have to relate that in September 2008
I received a 'phone call from his daughter saying that her father had passed away.

I hold many fond memories of Martin, and he will be sadly missed. As I researched
my *Mystery Animals* book, and the story of Wandering Willie, Martin always made time
to talk to me. He also provided me with a number of photographs, which he kindly
allowed me to use both in my column and in this book.

Over the years many readers have provided me with some incredible tales, and Martin
always took the opportunity to ring if he thought he had something of interest to share.
He also gave me a copy of his CD, and one only has to listen to it to sense the bond that
existed between this wonderful character and his dear wife.

Martin's family will miss him dearly, and so will I. The sun eventually set upon
Wandering Willie, and I can't help but think that somewhere the mischievous scamp is,
as I write, making a brand new friend in the shape of Martin Embleton. Jackie and I
attended his funeral, and family members told me that a copy of my *Mystery Animals*
book had been placed inside Martin's coffin before he was buried. I was deeply touched
and agreed that it is what Martin would have wanted.

What can we learn from this amazing tale? A lot, really. We can see, certainly,
the psychic bond that exists between a shepherd and his dog, the almost human
temperament of Wandering Willie and, undoubtedly, the fact that animals are far, far
more intuitive than we give them credit for.

ASTRAL PROJECTION AND NEAR-DEATH EXPERIENCES

One subject that has received, admittedly scant, attention in my newspaper columns is the curious phenomenon of Astral Projection. Hopefully, I can now attempt to put that right.

BACK! BACK!

Some years ago I received a letter from 'WraithScape' fan David Keedy, who was at one time the astronomy correspondent for *The Shields Gazette*. David told me of a fascinating experiment he'd once conducted in astral projection and wondered if it would make good material for my column. My readers weren't disappointed.

David carried out the first part of his experiment in 1965, seeking, in his own words, 'an objective or scientific approach to the question of astral projection, where the astral body (it is claimed) is purportedly able to project itself outside the normal, physical human body'. David waited till late one evening when it was all quiet and then carried out the experiment in his bedroom. Sitting quietly on the floor with his legs crossed, he closed his eyes and concentrated on the idea of a 'higher, non-physical body emanating from [his] physical body'.

David confessed to me that he didn't expect anything to happen. However, a moment or two later he felt himself 'rushing through a black void' and was terrified. He was, he told me, 'not in control of the situation' and remembers shouting 'Back! Back!' Moments later, David was relieved to find himself back in the safety of his own bedroom but shivering and in a cold sweat. To be honest I think that most of us lesser mortals would have been the same. Frightening though the experience was, David was determined to follow it through, so the next night he tried it again. The results were exactly the same: the 'black void', the sensation of hurtling through space and a 'rushing noise' in his ears. During this second 'space-walk', some disturbing thoughts occurred to David. What if he couldn't return to his own body? What if there were non-physical entities around who could actually *prevent* him from going back? Once again he found himself shouting 'Back! Back!' and he eventually returned to the safety of his own room.

Despite the fact that David didn't actually go anywhere during his experiments – at least not in a physical sense – the experiences seem to have had a profound effect on him. He told me that he was never afraid of anything after that, even when he nearly died of food poisoning in 1988.

David Keedy had an out-of-body experience in 1965. (Artistic representation)

David gained sufficient confidence to try a third experiment in astral projection, but nothing happened. Perhaps disheartened to a degree, he never did attempt astral projection a fourth time. David doesn't know what the experiences meant, although he genuinely believes that he did experience astral projection. Perhaps he has a natural ability to project himself out of his body. He admits that from the age of five he regularly experienced sensations of floating in the air. His final comment on the experiment? 'Out of this world,' he says.

I can vouch for that, for I once had an out-of-body experience (OOBE) myself and it was quite startling. One evening in 2001 I went to bed as usual and decided to read for a while. After fifteen minutes or so I felt drowsy and decided to go to sleep. Almost as soon as I closed my eyes something strange happened. Although I was completely relaxed I suddenly felt a vibrating sensation in the soles of my feet which slowly worked its way up my legs. Startling though the sensation was, I distinctly remember that I didn't feel frightened at all, just intensely curious. After a few seconds I also started to feel light, as if my body had no weight. Then it was as if I was floating upwards. I opened my eyes just in time to see the bedroom ceiling coming towards me, and I was convinced that I was going to bump into it quite forcefully. But I didn't; instead I just floated through it and, in an instant, found myself staring at the night sky.

Before I even had time to think about what was happening to me I levitated into a standing position before 'falling' to a horizontal position face-downwards so that I was looking down towards the ground. Then I started to move, and, to my utter amazement, I was flying like a comic-book superhero through the clouds. With every passing second my speed increased, and it felt as if I was travelling at hundreds if not thousands of miles per hour.

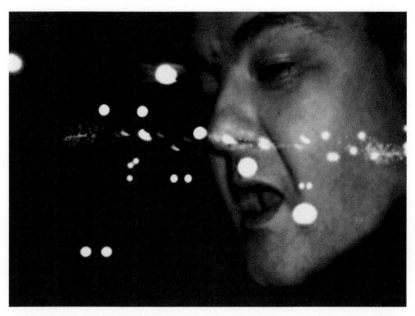

The author Mike Hallowell had his own out-of-body experience in which he could see himself flying over what looked like a beach resort at night. (Artistic representation)

At some point my speed decreased and I found myself cruising over a coastal area. Down below I could see a picturesque beach flanked by a long line of hotels. I also recall seeing a road illuminated by dozens of moving car headlamps. For some reason – don't ask me why – I just 'knew' that the location of the beach was somewhere in South America. Rationally, you'd think that I would have been terrified, but I wasn't. In fact, I felt elated and was thoroughly enjoying the experience. As I stared at the scene below me, I didn't notice that my speed was slowing all the time. Eventually I came to a halt and was hanging there, motionless. Then, ever so slowly, I began to drift backwards. It dawned upon me that the process was being reversed, and I was upset. I remember thinking, 'No! Don't take me back just yet! I'm *enjoying* this!'

But back I went, slowly picking up speed until I was shooting through the heavens, feet first, like a cruise missile. Before long I dropped back through the ceiling and into my physical body. I sat bolt upright in bed and realised that I'd had my own, *bona fide* out-of-body experience.

Several nights later I decided to try to initiate the experience. I lay back in bed, relaxed and tried to visualise floating through the sky. Nothing happened. However, two weeks later – again, just before I went to sleep – I once more felt the vibrating sensation in my feet. I was ecstatically happy and truly believed that I was going to go on another ethereal journey. It didn't quite work out that way. To my consternation, when the vibrating sensation reached my knees it stopped and then slowly faded away. My trip was effectively aborted before take-off. From that day to this I have never had another out-of-body experience, although I did have a near-death experience later, but that isn't quite the same thing.

Elaine Switt-Edwards found herself looking down upon her husband and her 'real' self during an out-of-body experience. (Artistic representation)

THE NAKED NEIGHBOUR

Elainne Switt-Edwards, from The Nook, sent me details of her own OOBE in 2003.

My husband and I were watching the TV one Sunday afternoon after lunch. The kids were playing out on their bikes. Suddenly I started to feel extremely relaxed and was surprised when my body started to tingle all over like it was vibrating. Before I could tell Tim [Elainne's husband] I seemed to jump out of my body and was floating face down just underneath the ceiling. It was weird. I could see myself sitting on the sofa next to Tim watching the TV, and yet I was up by the ceiling at the same time. I remember thinking, 'Oh, I'll go next-door and see what the neighbours are doing', and I did. I just floated through the lounge wall into their lounge. They were sitting watching the TV just like we were. The funny thing was that he had no clothes on. His wife was stitching a tear in his jogging pants, and he was sitting there without a stitch on waiting for her to finish. I remember looking down and giggling. I wasn't scared at all.

Elainne's story is intriguing, as she seems to have experienced exactly the same 'vibrating sensation' that I went through during my own OOBE. The cause remains an enigma, but I have to confess that if I got the opportunity to do it again I would in a heartbeat.

NEAR-DEATH EXPERIENCES

In December 2005, I had my own near-death experience, or NDE. I'd had an undiagnosed heart condition which eventually brought my ticker to a grinding halt, but

was fortunate enough to be sitting in the coronary care ward of our local hospital at the time – now *there's* good timing for you. I now have a pacemaker fitted and am doing just fine, but the interval between my heart stopping and being revived again was the really interesting bit. I found myself lying in a field on a hilltop wrapped in a bearskin, with three people standing at my right-hand side. I have no objective way of proving this, but something deep inside told me that they were ancestors of mine from a time long, long ago. I'm convinced that I briefly journeyed to the next world and then came back again because, to use the old maxim, 'It wasn't my time'.

One of the most enduring mysteries, of course, concerns exactly what happens to us when we die. Do we simply become non-existent, our mind and personality evaporating once the body ceases to function? Or does something – our consciousness, our soul, call it what you will – live on? Most religious people believe in the notion that the soul or spirit of a person survives the death of their body and goes on to some form of afterlife. Others believe that the end really means just that – the total cessation of the person in every respect.

Truth to tell, I used to be a firm believer in the latter. When someone died, I assumed that their existence was completely terminated. Now, however, I firmly believe that there is a form of conscious existence after death.

Many people who have near-death experiences report travelling down a tunnel towards a bright light, and seeing deceased relatives waiting for them at the other end. (Artistic representation)

Recent research has shown that those who have been clinically brain-dead before being revived in hospital were able to recall things that occurred after their brain had seemingly ceased functioning. If the consciousness of a person exists independently of the body then this would make sense, of course. Another argument in favour of the idea that the mind survives the death of the body is that people of all races, cultures, religions and social strata have exactly the same stories to tell when they regain consciousness. They all report travelling down a tunnel, seeing a bright light, being greeted by deceased

relatives, and so on. Some witnesses have, independently, even described the exact same topographical features of the afterlife.

Of course, spiritualists have been saying this for years. They have always had an unshakeable conviction that the soul or spirit survives the death of the physical body. An interesting case I heard recently demonstrates just why such an idea is compelling.

Motorists in South Shields claimed to have been flagged down by the ghost of a girl who had died in a motorcycling accident. (Artistic representation)

Some years ago a number of motorists from South Shields, on a particular stretch of road, reported being flagged down by a distressed woman. Both she and her boyfriend had been thrown from their motorbike when it skidded, and her companion needed help as he was unconscious. The motorists would invariably get out and go to the spot where the accident had taken place, only to find no motorbike and no unconscious man. Alarmingly, however, when they turned around to talk to the young woman, they would find that she too had disappeared.

I was told that there had indeed been an accident on that very spot some years previously. Chillingly, I also discovered that, although the man had recovered, his fiancée had been killed instantly. A similar story from South Africa was also later related to me by a reader.

One can understand why investigators suggest that the spirit of the dead woman carried on acting in exactly the same way she would have done had she not died. Had she survived unscathed, she would undoubtedly have tried to flag down a passing car and summon aid for her boyfriend. This leads us to conclude that, bizarre though it sounds, she was not aware that she herself was dead.

Anyone who has seen the film *Sixth Sense* with Bruce Willis will understand how surreal this seems – both for the dead and the living. If the dead really do survive the corruption of the physical body then many deep and profound questions spring to mind. Where are they? What sort of existence do they enjoy? We don't know all the answers, but those who have had near-death experiences will tell you that the fear of dying evaporates completely.

CHAPTER 4

DOWSING

Some years ago, Mike Byrne, a paranormal investigator from Norwich, showed me how to use a set of dowsing rods. I'd always been sceptical about the practice, but that first experience converted me to the ranks of the believers.

The art of dowsing goes back centuries, if not millennia. Most readers will have seen pictures of dowsers using a Y-shaped twig to detect water – a practice associated with 'country folk'. Often derided as silly superstition, dowsing actually does work. In fact, several scientific theories have been put forward to explain it. But let's not get ahead of ourselves. First of all we need to establish exactly what dowsing is.

Dowsing – sometimes called divining – is simply a method of detecting things hidden from view. Exactly how it works is debatable, but the usual method is to hold a twig (or two L-shaped rods) with both hands and then walk around the area you are searching. When the twig or rods start to twitch or swivel, then the thing you're looking for should, in theory, be beneath your feet.

Let's imagine, for example, that there was an underground stream running under your farm. You'd like to tap into this natural resource but you don't know where it is located. The answer? Walk around the field holding your dowsing rods in front of you and when they suddenly take on a life of their own, you can start digging. I've grossly oversimplified the process, but that's really the gist of it.

Dowsing can be used to find lost objects and, chillingly, dead bodies.

Running water generates energy and some researchers suggest that sensitive individuals may be able to detect it. The dowsing rods simply act as receivers, concentrating that energy and directing it into your hands, thus causing your muscles to twitch involuntarily and make the rod move.

Well, that's another theory. As I walked across the lounge of a busy public house with what looked like a bent coat hanger in each hand – not even drawing so much as a raised eyebrow from the patrons, who had obviously seen this all before – I was amazed to find that the two rods suddenly swung in and over quite sharply and crossed like two unsynchronised windscreen wipers.

When the rod in my right hand started to swing like a spinning top in another part of the pub, Mike looked quite puzzled. Then he saw an electric cable from an extension lead lying on the floor underneath my feet. He asked someone to turn it off, and immediately the rod stopped swinging.

Mind you, experienced dowsers can find more than just water. They have successfully located, amongst other things, dead bodies, diamonds, the buried remains of crashed aircraft and the odd bit of Roman treasure for good measure.

In response to my article on dowsing, I received a letter from a gentleman in Harton Village who, until his retirement, worked as an area chief engineer for the National Coal Board. What he told me was fascinating.

In the early 1960s it was decided to use our HQ's architects to design and build a central office in Spennymoor. This meant transporting all material from the old offices to the new one. I noticed amongst the drawing office equipment a very nice wood box, which I had not seen before. I was told it contained the Area's official dowsing rods. I suspected a leg-pull, but when it was opened it contained two chromed cylinders into which were fitted L-shaped chromed metal rods. The cylinders had attached to them tubes of various materials, e.g. copper, iron, ceramic, etc., about six in all. They could be hand-held so that the rods were horizontal, and attached tubes of a chosen material could also be held in the palm of the hand.

I was very sceptical, but on entering the new offices we found the architects had not sent us maps showing the positions of the various services on the site, such as water, electricity, drains, etc., so I asked the draughtsmen to provide us a map using the dowsing rods. Only two of about eight draughtsmen could get results from the rods. They were marked along their length, and when used the mark along the rods at the point where they met indicated the depth of cover over the detected item. The map they produced was almost identical to that which we got later from the architects, and in some instances it was more accurate because the building contractors had not stuck to their plans.

A few years later I was at the NCB's staff college at Longbenton and told this story to a gathering of other senior engineers. They were so sceptical I actually sent for the rods and a man who could use them and gave a demonstration. I got each engineer in turn to press a coin into the lawn and asked the diviner, who had not been present, to find them. This he did, except for the final coin, which had been in the possession of the most sceptical person present. We apologised for this failure, but he replied that we had convinced him. He had actually put the coin in his pocket whilst pretending to bury it in the lawn.

Sceptics have a hard job when confronted with testimony such as this. As for the engineer who sent me the story, he says that, 'there is no doubt in my mind that they worked, as they were used successfully on several other occasions in my presence'.

CHAPTER 5

DREAMS AND PREMONITIONS

Everyone dreams, and the vast majority of people – whether they admit it or not – will at some time have one or more premonitions about future events. What causes these experiences is debatable, but the fact remains that many individuals have come forward and claimed to have witnessed the future with chilling clarity. Of course, if those who have such dreams and premonitions only announce their contents after the event then there is no way of knowing whether they really saw it in advance or not. Some dreams and visions do not predict the future, however, but seem to give the experient a glimpse into the past. It seems that the dream state enables some people to step out of time and see events that are dislocated from the present.

Since the dawn of civilisation people have been fascinated by dreams. The ancient Egyptians, for example, believed they were given to us for guidance. What purpose do they serve? Can we make use of our dreams or maybe even control them? Can dreams predict future events or warn us of impending disasters?

There is little doubt that dreams serve a purpose, otherwise we simply wouldn't have them. In experiments, subjects who were prevented from dreaming – by being woken just as they were about to enter the phase of sleep in which dreams occur – became disoriented and unable to think clearly. Some even began to hallucinate.

One common theory is that dreaming acts as a sort of 'file manager', sorting out the events that have cluttered our day and organising them within the brain. The content of our dream is said to be the 'unusable' material, which is left over. The brain deals with this by putting this jumble of rubbish into a logical format – literally creating a story out of it and then getting rid of it by 'playing it out' in our mind. This is like someone who collects old matches, lollipop sticks and bottle tops and makes them into a model boat. When the boat is completed the rubbish that made it has disappeared. The maker then gets rid of the boat by giving it away as a present.

Sometimes such dreams can be quite amusing, as in the case of a friend of mine who had a 'vivid' dream that he was throwing dozens of bananas at a vicar who was trying earnestly to catch them in a straw hat. To make matters worse, they were both standing in the middle of a football stadium in front of a capacity crowd. I told him to keep taking the tablets. But not all dreams can be explained in this way. Some dreams are repetitive, occurring over and over again. Such dreams tend to be extremely intense, occasionally leaving the dreamer confused on waking between what is real and what is only 'dream stuff'.

Actually, it is possible to control our dreams. Some fortunate people seem to be born with an in-built ability to do this, and researchers call it 'lucid dreaming'.

Normally we have little control over our dreams. It is almost like being at the cinema, and we may watch events as they unfurl but cannot alter them. When we dream, we

are simply actors acting out a role. But lucid dreamers can control their dreams. They can decide where they go, what they do and what they say. Those who experience such dreams say they are enjoyable, even 'fun'. This type of dreaming is not unlike the out-of-body experiences detailed earlier, in which experients say that they can actually leave their physical body and roam around at will. This type of experience is sometimes known as 'astral projection' and it is a highly controversial subject.

Some sceptics believe that 'astral travellers' are simply experiencing a very intense form of lucid dreaming and there is some evidence to suggest that this may be true, although certainly not in all cases. In one instance a volunteer was asked to describe in detail where he had travelled to in his sleep. He described the scene with uncanny accuracy, but nevertheless certain crucial but minor details were wrong, such as the layout of some cobblestones and the colour of a shop door-handle. It seems that the volunteer's brain, using past memories, was able to reconstruct an image of the location in almost perfect detail, fooling the astral traveller into thinking that he was actually visiting the place in his sleep. In fact, he was probably just lucid-dreaming.

But not all cases of astral projection are explainable in this way. On occasions, the 'traveller' describes details and events that could not have been discovered by the normal senses. A woman undergoing major surgery in a US hospital told nursing staff later that she had had an 'out of body experience' whilst on the operating table. According to the lady she had floated up to the top of the hospital and could see the roof. The doctors just put this down to an effect of the anaesthetic, but the woman knew better. During her journey, she claimed she had seen an old hospital gown lying on a ledge on the hospital roof. She described the colour, pattern and condition of the gown in explicit detail. A porter was despatched to take a look and, sure enough, there it was: the self-same gown in exactly the same place.

Hospital officials later admitted that there was no way the woman could have seen the gown by normal means, as the ledge was only visible from a part of the hospital to which the public had no access.

We cannot rule out the possibility that, under certain conditions, our minds may have the ability to remotely view distant places. One can only wonder at the potential of such an ability, if only it could be harnessed and developed. The line between lucid dreaming and astral projection is tenuously thin, and my guess is that the two phenomena are intrinsically connected.

Native Americans often use a dream-catcher to 'catch' bad dreams before they enter our head. I know several people in South Tyneside who have used them after being plagued by disturbing dreams, and who swear that they work. People who are persistently plagued by disturbing dreams may need to pay a visit to the doctor for a check-up. Sometimes something as simple as a faulty diet can be the cause.

PREMONITIONS

Premonitions are basically glimpses of the future, a peek along the time-line during which we see things that have yet to occur. Just as lucid dreaming and astral travel are closely connected, so are dreams and premonitions.

Not all premonitions come in the form of dreams. Some are experienced whilst the subject is very much awake. Keith Wallace had a premonition whilst driving, forcing him to pull in to the side of the road sharply:

Keith Wallace saw a 'TV screen' appear on his car windscreen while driving through Whitburn. It contained a visual premonition of a tragedy. (Artistic representation)

I was driving through Whitburn, and suddenly [saw] what looked like a TV screen right in front of me. I got no warning and had to pull the car into the siding and slam the breaks on. I'd never experienced anything like it. On the 'screen' I could see these people walking along a path on the side of a hill, or maybe a mountain. They looked like ramblers or hikers. All of a sudden one of them, a woman with blonde hair, fell over the side. I can remember that she had a red jacket on. The others were panicking and waving their arms about. They looked as if they were in a real state. Suddenly the 'screen' disappeared. I thought I was going mental, or something. I planned on going to see the doctor to tell him, because I thought there was something wrong with me. The next day I was watching the news and this report came on about a woman who had died in a climbing accident in Scotland. They showed a picture of her which a friend had taken the previous day with his camera. The woman had blonde hair and a red jacket on.

Most premonitions, however, do present themselves as dreams. I once had an intensely vivid dream in which I saw a jet fighter crash into a shopping centre at night. In my dream I saw dozens of people (some with their hair and clothes on fire) running away from the scene of devastation. I woke up in a cold sweat. But could this be classed as a premonition? Well, if it ever happened in real life then I suppose it would. In reality, I believe it was simply a vivid dream, brought on by an unusually busy and tiring day. It was frightening nonetheless.

Sometimes, though, dreams can act as a warning that something terrible is going to happen. On 27 June 1914, Balkan Bishop Monsignor Joseph de Lanyi dreamed that he was in his study gazing down at his desk. On the blotter lay a letter edged in black, and in its centre lay the crest of Archduke Ferdinand, heir to the Austro-Hungarian throne.

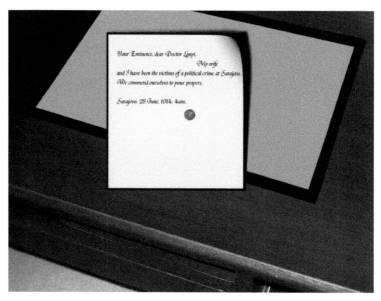

Your Eminence, dear Doctor Lanyi.

*My wife
and I have been the victims of a political crime at Sarajevo.
We commend ourselves to your prayers.*

Sarajevo. 28 June. 1914. 4 am.

Balkan Bishop Monsignor Joseph de Lanyi dreamed that he saw a letter
lying on his desk blotter from Arch Duke Ferdinand announcing his murder.
The next day he found the dream had come true. (Artistic representation)

In his dream the priest opened the letter and, to his astonishment, the page became like a cinema screen. He saw the Archduke, his wife and three officers sitting in a car parked in a street. Suddenly, two men dashed forward and pumped bullets into the vehicle, killing the Archduke. The scene faded, only to be replaced by the text of a letter which read 'Your Eminence, Dear Doctor Lanyi; my wife and I have been the victims of a political crime at Sarajevo. We commend ourselves to your prayers. Sarajevo, 28 June, 1914, 4am.' On waking the Monsignor told his aides about the terrifying dream. Later in the day he was informed that it had all came true right down to the last detail. As a result of the assassination the First World War broke out.

Virtually everyone has had that 'I've been here before' experience, commonly known as *déjà vu*, at one time or another. South Shields-born long-distance lorry driver Arnold Marsh told me a strange tale about when it happened to him.

I had a delivery to do in Kent. It was lunchtime, and about twelve o'clock or so I pulled into this small market town for a bite to eat. I parked the truck and walked down the road towards some shops. As it turned out, they were all estate agents and building societies, so I decided to follow the road round the bend in the hope that I'd find a sandwich bar or a fish and chip shop. Just before I turned the corner I thought, 'Oh, I know, I'll go to that bakers, the one next to the model shop that sells miniature railways'. Sure enough, I turned the corner and there was this shop called Model World. In the window was a scale model train layout complete with miniature houses, stations, roads, etc. Next to it was the bakery. I went in and bought a mince pie and a peach melba. It wasn't till I came out that I thought, 'Hang on; how did I know that those shops were around that corner? I've never been here before.'

Arnold Marsh had to make a delivery in a small town in Kent. He arrived – only to realise that he'd psychically 'been there before'. (Artistic representation)

I put it to Arnold that maybe he had visited that town before and just forgotten. After all, as a long-distance lorry driver he whizzes all over the country. Wasn't it possible that he had passed through the town previously and had subconsciously remembered the model shop and the bakers? 'Everyone says that' he responded. 'People say, "You must have been there before", but I can assure you that I had never previously been to that part of Kent. It was new territory for me, and I had to refer to my road map continually. If I'd been before I know I'd have remembered some of the roads, the route, my purpose for driving through there or something, but I couldn't and the reason I couldn't is because I'd never been there before.'

I once had a similar, although not identical, experience some years ago. One night I had a vivid dream that I was standing in a country village on a sunny afternoon. I was standing at the roadside looking across a grassy verge with houses at the other side. I could see the houses, trees, cars and people with crystal clarity. For some reason this dream made a vivid impression on me, and it didn't 'fade away' as dreams normally do. Several years later I happened to pass through the picturesque village of Staindrop in County Durham, a place that I'd never been to before in my life. I turned a corner and suddenly had the urge to stop the car and get out. There, ahead of me, was the village that I'd seen so vividly in my dream years previously. It was identical right down to the finest detail.

To be honest, I found this experience so weird that my head started to spin. I had never been to Staindrop before. 'Ah, but you *must* have been before', the sceptics will say. Now I know how Arnold feels.

And then there's the case of Michelle, a doctor's receptionist. Michelle works in Newcastle, and one day last summer she was travelling by bus to Heworth metro station when the engine began to make grinding noises. Suddenly, the bus shuddered

to a halt. The passengers had just disembarked to wait for a replacement bus when, as luck would have it, a colleague of Michelle's passed in her car and offered her a lift. 'We went through a part of Felling I'd not seen for ages' says Michelle, 'and yet I suddenly found myself wondering whether the builders had finished renovating an old house further up the road.' Seconds later the house came into view and I could see that the scaffolding was still up and piles of bricks were still standing on the pavement. 'I just don't understand how I knew that the house was being renovated. The strange thing is that when I saw the house in real life it was exactly as I'd seen it in my mind's eye a minute earlier, right down to the pile of cement beside the fence'.

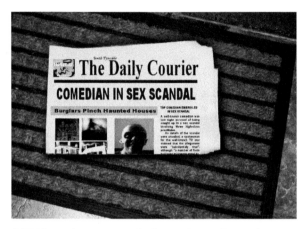

A Hebburn shop assistant had a predictive dream about a scandal involving a well-known TV personality. (Artistic representation)

Alan is a nineteen-year-old sales assistant from Hebburn. At the weekend he often stays at a friend's house in South Shields – a few beers, a good film and plenty of laughs. Typical behaviour for many people in their late teens, actually. But one year, on Saturday 30 January, things turned out a little differently. The friends stayed up late playing computer games, finally 'hitting the sack' in the early hours of Sunday morning. Alan was spending the night in the spare room and fell asleep almost as soon as his head hit the pillow. What happened next disturbed him greatly.

At some point after daybreak Alan began to wake up. He can't remember the time exactly, but suspects it may have been around seven o'clock. Like most people when they awaken, Alan went through that dozing period where one is neither fully asleep nor fully awake. During this period of time – which on rare occasions may last for up to two hours – the mind may be deluged with images, thoughts, memories and dreams.

As Alan lay in bed in a deep state of relaxation, one particular memory popped into his head as if from nowhere. He recalled watching a science fiction series on satellite TV some months earlier which involved a man who found a newspaper lying on his doorstep every morning. The twist to the tale was that the newspaper was actually for the following day, which meant that the man who received it so mysteriously could predict disasters in advance, forecast which horse would win a race, and so on.

Alan states that he has no idea why he should have started to think about this rather obscure TV series whilst lying in bed early on a Sunday morning. However, what he remembers clearly is that this memory was followed by a stark image of a national Sunday newspaper dated Sunday 31 January – that is, for the following day. In his dream-like state, Alan was able to read the headline on the front page, which referred to a sex scandal involving a well-known TV comedian. The vision was so intense that it woke him up completely.

Alan takes up the story:

> When I sat up in bed I felt strange – weird, in fact. I knew that this had not been an ordinary dream. I just had this overpowering feeling that the newspaper headline I saw was real. I got out of bed and went downstairs. I could see the Sunday newspaper lying on the mat in front of the door. Strangely, my friend's mother had the same newspaper delivered that I had seen in my dream. I picked up the paper and turned it over, knowing what the headline would be. Sure enough, there it was – a sex scandal involving the same TV comedian. It was spooky.

Alan felt physically sick after his premonition, and I asked him why. He told me that it was just the shock of something so strange happening to him, and something which he can neither rationalise nor explain. This is a common reaction with people who have premonitions. They become frightened because they feel that they are no longer in control of their own mental faculties. The fact is that people do not like strange thoughts and visions invading their mind without warning!

Explanations for mysteries such as precognition – to give *déjà vu* its proper title – vary. I found one of the best I've come across whilst supping a pint in the Stanhope Hotel in South Shields. I find it rather ironic that some people travel the globe in search of the answers to life's mysteries, and I find one sandwiched between a packet of pork scratchings and a pint of bitter. It's a funny old world.

My drinking companion was a student of theoretical physics, and I asked him if he felt there was a scientific explanation for precognition. There was no doubt in his mind that there was. 'It's like this,' he began. 'Nothing's perfect, right? Every facet of nature has a flaw in it. The stars glide through the sky beautifully, but every now and then one goes bang. The weather can be stable for ages, and then all of a sudden thousands of people in Bangladesh, or wherever, find themselves waist-high in floodwater. Either that or they'll get no rain for six months.'

'It's like every part of nature has an "instability chip" built into it. Nothing works perfectly forever. Maybe time is like that. Everything ticks over swimmingly for a while, and then, all of a sudden, there's a minor hiccup and a little bit of past, present and future get thrown out of sequence. That's all precognition is: a hiccup in the time line. Nothing to worry about, really.'

It is easy to put too much stock in dreams. Just because a dream may be intense that does not mean to say that it is a premonition of future events to come. People who have such dreams often worry about them, waiting for the 'fulfilment' to occur. This is not a good thing. Dreams should not govern our lives. Some people have predicted disasters in their dreams, however. The *R101* disaster, the sinking of the *Titanic* and the murder of Abraham Lincoln were all predicted with crystal clarity in the dreams of one or more persons.

The mechanism by which dreams can become predictive is not understood. One theory is that as we enter the sleep state our minds are more open to receive messages

from paranormal sources, whether by telepathy or some other means. Another researcher has suggested that in a deep state of relaxation we may occasionally 'jump the time barrier' and gain a glimpse of things to come. Precognitive dreams would be ideal if we could 'turn them on to order'. Just think – you'd know who was going to win the Grand National every year before the race had even started! Unfortunately dreams aren't like that. We just don't know when they're going to 'play', turning our mind into a temporary theatre.

Colin is a good friend of mine who lives on the Biddick Hall estate, South Shields. Some months ago he told me of a series of strange coincidences – if, indeed, such they were – which had occurred throughout his life. When he was fourteen years old, Colin went to stay with an aunt in Bridlington for a holiday. For two happy weeks he explored the town and made some new friends. Then, after kissing his aunt goodbye at the train station, he returned home to South Shields. Two days after he came home, Colin was woken up in the middle of the night by the sound of his mother's voice calling, 'Colin! Colin!' Quickly he got out of bed and went to see what she wanted. To his astonishment, his mother and father were both sound asleep. Colin put his experience down to dreaming. Maybe he had imagined he'd heard his mother's voice. Or maybe his mother really had shouted out in her sleep. Perhaps she'd been dreaming. The next day, Colin came in from school to be informed that his aunt in Bridlington had died suddenly of a heart attack during the night. Naturally he was very sad, but did not connect his aunt's death with the voice he'd heard during the small hours of the night. Not until, that is, his uncle Sammy died two months later.

A resident of Biddick Hall regularly heard voices in his sleep which always presaged a death in the family. (Artistic representation)

Colin had been close to his uncle Sammy, who would take him into his shed in the garden and show him how to use carpentry tools. In his spare time, Colin made a beautiful coffee table for his mother. Even Sammy said it was an excellent first attempt. The voice was the same. It was his mother's voice shouting 'Colin! Wake up, Colin!' With a start he jumped out of bed and ran to his parents' room, only to find them both sleeping soundly as usual. Mystified, he went back to sleep. At 2pm the next day, Colin

was informed that his uncle Sammy had died of a suspected brain haemorrhage. It was at this point that he began to wonder whether the voices had meant something. Two close relatives had died and on each occasion he had 'dreamed' that he had heard his mother's voice calling to him in his sleep.

As the years rolled by, Colin began to accept these warnings in a matter-of-fact manner. When he heard the voice, he resigned himself to the fact that, within a day or two, a member of his family would pass away. Colin still hears the voices, even though he is now well past retiring age and his mother died long ago. It last happened five months ago when his sister, Ellen, died of cancer. 'We had been expecting her to die for some time', said Colin, 'but not as suddenly. When I was woken up in the night by the voice – it was my mother's, even though she was dead – I knew what it meant. I rang my other sister immediately and she said that the hospital had just asked her to go in straight away. It turned out that my other sister had died at the same time I heard the voice.'

I've made a fair few appearances on the Beeb over the years, talking about everything from sea monsters and secret tunnel systems to those who have had 'near-death experiences'. It's all good stuff and I was encouraged to see a Liberal Democrat MP come forward on one show to talk about his own strange experience with the unknown. I remember the time when most folk were frightened to admit having seen a ghost, or perhaps having had a close encounter with a UFO, but not so now.

Tracey McGarvie, a sales assistant, is a typical example. When Tracey was fourteen she had a very strange experience, which she had steadfastly declined to talk about until the day I interviewed her. 'I didn't want people to think I was daft', she told me. 'Well, you're not daft', I told Tracey, and I was happy to tell other readers her tale for the first time. One day, whilst walking home from school, Tracey was stopped by a rather scruffy looking man whose breath stunk of stale beer. He pointed down the street and said to Tracey, 'See? See down there, love? There's going to be a right old car smash down there tomorrow, you mark my words! Big red 'un and a little blue 'un – bang!' The old tramp then mumbled something about 'silly beggars' and stumbled off down the street.

When Tracey got home she mentioned the incident to her mother, who simply told her not to talk to strange men in the future. The next day passed uneventfully, with no car crash. The following day, however, the tramp's prediction was fulfilled with unnerving accuracy. A blue mini and a larger red Datsun collided in the street, causing severe damage to both vehicles. Tracey told me, 'I'm glad I told people about what the man said before it happened, otherwise I don't think they would have believed me.'

Maybe, maybe not, Tracey, but the times they are a-changin' and far more people are open to the notion of paranormal phenomena than ever before. Maybe there's some truth in that old adage that the world is not just stranger than we know, it's stranger than we can know.

There is a positive side to premonitions, however. Those who have them regularly often get used to the idea and eventually look upon their ability as a gift with which they can help others. Several police forces in the USA use psychics to help them solve difficult crimes, and in the United Kingdom one hardened detective has admitted on national TV that he uses his own psychic powers to help him in his work. The same officer recently wrote a book about his experiences.

Unfortunately, most alleged premonitions are not meaningful. In fact, the vast majority concern relatively trivial events, such as meeting an old friend or finding a set of keys mislaid months ago. What causes premonitions? The fact is that we don't really know.

Several South Tynesiders have heard the Banshee announce a forthcoming death. (Artistic representation)

All we can say for sure is that some people do have the ability to glimpse the future. Whatever the cause, those who possess this strange talent can't simply 'turn it on and off like a tap'. Premonitions, it seems, cannot be called to order. They come suddenly and unexpectedly. In fact, one psychic told me, 'the harder you try the less it works. I've had hundreds of premonitions, and every one has happened when I least expected it.'

No one really knows why some people receive warnings or premonitions when tragedies are about to occur, but it is known that some races of people seem more disposed to them. People of Irish descent, for instance, can often relate tales of how the death of someone close was heralded by the sound of a woman's voice screaming and/or wailing in the distance. This phenomenon – often referred to as the 'screaming banshee' – is taken seriously by many, and those who have studied it often become convinced that it is no mere myth or legend. I have personally talked to two people from Northern Ireland who claim to have heard the Banshee, and I have no reason to doubt their stories.

CHAPTER 6

EERIE VOICES FROM BEYOND

Thomas Alva Edison is well known as the inventor who brought the electric light to America and introduced to the world the phonograph, the duplex telegraph and an early form of motion picture called the Kinetoscope Parlour. What is less well known is that Edison was working on another device – one that he was convinced would enable the dead to talk to the living freely. Edison believed that our personalities in the world beyond actually had the ability to affect matter. Further, he believed that it should be possible to build a device that could pick up on the interaction between the spirit and the physical world. Edison, for the rest of his life, worked on devising such a machine. He was unsuccessful, but another scientist was to have far better luck.

In 1959, the famous Swedish painter and film producer Friedrich Jürgenson took a portable recorder into the woods to tape some birdsong. When he played the tape back he was astonished to hear voices discussing – ironically – the subject of birds singing. Jürgenson at first assumed that he'd picked up stray radio signals, but on a second attempt he actually recorded the voices of deceased relatives who spoke to him by name. So fascinated was the artist that he wrote a number of books about the phenomenon, and a copy of one found its way to Professor Hans Bender in Frieburg, Germany. Bender then began his own experiments.

Meanwhile, a distinguished Latvian scientist called Konstantin Raudive also began experimenting and was destined to become the 'father' of the Electronic Voice Phenomenon. Working with the renowned physicist Dr Alex Schneider and Theodor Rudolph, an expert in high-frequency electrical engineering, Raudive recorded tens of thousands of disembodied voices. Raudive's heterodox approach caused uproar amongst the straight-laced scientific community.

One of the big complaints that sceptics often make about paranormal phenomena is that there never seems to be any real proof that anything strange has actually happened. Believers find this as irritating as the cynics, believe me. 'If only we could capture a ghost on film,' they say, 'or if only we could actually capture an alien spacecraft.'

Well, quite. Mind you, the day when we are actually able to prove the existence of certain anomalous phenomena may not be far off. Technological advances are enabling researchers to collect evidence which only a few years ago would have been difficult to obtain. Amongst these phenomena is, of course, that strange manifestation known to researchers as EVP.

EVP normally manifests itself in a location that is said to be haunted and/or suffering from poltergeist infestation. Usually, a researcher will have taken a tape-recorder along to interview the witnesses, and afterwards, when playing the tape back, he or she will hear strange voices that were not audible at the time the conversation took place.

EVP voices have strange characteristics. Occasionally they will speak in several different languages in one short sentence, making translation difficult. Another common characteristic is that the metre and tone of the voice will be odd. One disembodied (female) voice I was asked to listen to sounded as if it was saying 'hi, love, there's a plate'. After listening to this apparently nonsensical message several times it became clear, however, that the voice was saying 'I love this place'.

Researchers find that it takes a while to acclimatise their ears to the EV phenomenon. Once this is done, however, the messages can often be heard quite clearly. Sometimes EVP messages can be frightening. In one case a couple plagued by poltergeist phenomena asked an investigator to help as they had heard strange, disembodied voices whilst having a picnic in the garden. He interviewed them on tape. At one point, the investigator and the female householder were discussing the woman's feeling that she should leave home with her children, as she was worried the poltergeist would harm them. When the tape was played back later, a gruff male voice could be heard saying 'you go, they stay. Dead in two days.'

Some people believe that disembodied voices are caused by demonic entities. (Artistic representation)

So what *are* these disembodied voices? The truth is that theories abound but no one really knows. To many Christian fundamentalists they are the work of demonic spirits. To other researchers they present themselves as the spirits of dead people who have not yet gone on to their new home in the spirit world. Me? I have a different idea. Personally I think that such recordings may be the voices of discarnate spirits, but they could also simply be another manifestation of the poltergeist phenomenon. Like the poltergeist, disembodied voices may really be a paranormal projection from the mind of a depressed or angry person. Although we can't be sure, they need not necessarily possess sentience or conscious existence.

Sometimes disembodied voices seem to mirror the deepest fears and anxieties of their victims, and this gives us a clue as to where the sounds may originate. Does this mean that those who create these strange voices know what they are doing? No, the victims of poltergeist or EVP are *not* to blame for what is happening, and there may be some evidence to suggest that one person on their own cannot produce the full range

of poltergeist or EV phenomena researchers are accustomed to seeing. In actual fact it may take two or more people acting in unison, subconsciously and unbeknown to themselves. (Confused? Then try doing my job for just one week and then see how you feel!) Seriously though, it must be remembered that whatever the source of poltergeist or EV phenomena they rarely do any harm to the victim. They are frightening but essentially harmless manifestations of telekinesis or 'mind over matter'.

Some time ago I heard of a South Shields case in which a man kept hearing voices coming from – of all things – the toaster in his kitchen. Suspecting that he was suffering from some form of mental illness, he promptly paid a visit to his GP. One would have imagined that the doctor would have prescribed him something and referred him to a psychiatrist, but he didn't. 'This voice that you hear... does it keep telling you over and over again that you're going to die?' Dumbfounded, the man replied in the affirmative and asked how the doctor knew. 'The chap who lived in the house before you was also patient of mine. He heard exactly the same voices.' In a strange sort of way, this made the man feel better. It wasn't him, it was the house.

Over the last few decades, researchers have actually devised several ways of recording EVPs. One method simply involves tuning your transistor radio into the 'white noise' between stations and recording the sound for half an hour. Often, when played back, voices can be heard in the background. Researchers can then use modern technology to 'clean up' the recording so that the voices are easier to hear. Often the results are astounding.

By tuning in to the 'white noise' between radio stations some say it is possible to tune in to the voices of the dead. (Artistic representation)

There are several strange anomalies surrounding the EVP mystery which have not been satisfactorily explained. One peculiarity is that the sentence structure, although understandable, is usually 'awkward'. Recently, two security guards in Chicago saw a light go on in a building across from the room in which they were stationed. When one drew this to the attention of the other, they were both amazed to hear a voice come out of their radio saying, 'Seen us. Depart must'. This odd, dislocated language is typical of the EVP phenomenon.

People have also heard disembodied voices emanating from TV sets
– as well as seeing images of dead people. (Artistic representation)

Another curious thing is that disembodied voices rarely seem to carry any profound messages out or spout forth any deep philosophy. Most of the time the recordings just capture snippets of conversation about trivial things. One lady kept hearing disembodied voices emanating from her TV set. On one occasion she was sitting sewing when the voice said, 'She'll poke herself with that needle, mark my words'. The woman didn't poke herself with the needle, but was still shocked at hearing the voice as she was at home on her own. Further, the TV set was switched off at the time.

Years ago, an elderly couple from Harton Village contacted a local newspaper and asked me if I'd like to hear a 'strange recording' they'd made in their living room. The chap had been trying to record some opera music off the radio onto a portable recorder, and, on playing back the tape later, was disturbed to hear a disembodied voice in the background. I sat and listened to the tape with a reporter, and we quickly became convinced that it was genuine. On the tape, just as the music fades out, there are three, sharp clanking noises followed by a female voice which says, 'Turn that off! It's terrible! I can't stand that!' I was heartened to find that the entity behind the disembodied voice shared my dislike of opera, proving that I'm not the only musical philistine in the country. I grilled the couple for half an hour, and both were adamant that no one other than themselves had been in the room at the time and that they did not recognise the voice at all.

Fellow author Darren W. Ritson has had his own encounters with disembodied voices. Some time ago, Darren, his colleague Suzanne McKay and several members of another ghost-hunting team visited an allegedly haunted building in County Durham. Something strange certainly seems to be going on there, although the present owners are so concerned that they have asked for the location to be kept a strict secret. What I can tell you is that the building is attached to an old church and is still in use today, although not for religious purposes. Unusually, there have been no reports of any ghostly happenings in the building to date.

Darren, Suzanne and the others had merely visited the place to carry out some diagnostic tests in the hope that if there were any resident spooks they'd put in an appearance.

On arrival the team set up camp in the main hall and turned it into their base room. Almost as soon as their investigation began, Suzanne, who is psychic, said she could sense the presence of a man who was simply interested in what they were doing. Mind you, just what Darren and the others would have done if the ghost had asked for a membership form is open to speculation. Throughout the night, numerous strange things happened that Darren and the others found difficult to explain. Strange lights were caught on camera, and, bizarrely, an overpowering aroma of fresh fish filled the building in the middle of the night. Darren and Suzanne both heard the distinct sound of 'rustling paper' at the same time. Now it just so happened that Suzanne had earlier detected the presence of another spirit in the building. This one was female, and Suzanne felt that there was a strong connection between this presence and the name Murphy. A flight of fancy? Probably not. Later, one of the investigators made a chilling recording of a disembodied voice pleading, 'Can you help me?' The voice was female and had a distinct, Southern Irish accent.

Other disembodied voices were also recorded. On one, what sounds like the same woman can be heard saying, 'Nighty-night then; the night is over'. Yet another recording was picked up someone simply saying, 'Pick me up'.

Darren later recalled that 'They are still a mystery but many people believe we have recorded the voices of ghosts or earth-bound spirits that are indeed calling out for help, as if they are trapped between two worlds. Perhaps we have, but one thing is certain: on the night, when we heard them for the first time, our blood ran cold!'

Quite, but what chilled Darren even further was when the same disembodied voice actually called out to him by name! 'To hear a recording of a ghost or spirit is one thing, but to hear one call your name is something else.'

THE HAUNTED CANAL BOAT

It's not uncommon to come across tales of haunted ships in my line of business, but haunted canal boats are something of a rarity. However, I recently received an intriguing email from Linda and Lonnie Loft of South Shields who had a very strange experience indeed last year whilst sailing through Warwickshire.

The boat the family hired was an attractive one, and the Lofts, thoroughly enjoying their excursion, moored in Atherstone on Wednesday 13 August. They had all had settled down for the evening, as everyone was tired because they were travelling around the entire 'Warwickshire Ring' in just seven days. The eldest and youngest daughters were sleeping at the front of the boat, whilst Lonnie and Linda were berthed in the middle. Their son Craig, sixteen, along with the second eldest daughter, were sleeping in the bow.

As darkness fell, Lonnie suddenly realised that he could hear something coming through the adjoining wall – it sounded like Craig breathing. He roused Linda and told her to listen, but Linda, confused, said it couldn't be Craig as he wasn't sleeping in the next room. 'Lonnie... the bathroom and shower are next door,' she said, 'not the beds!' Mystified, the couple didn't think too much about it and eventually drifted off to sleep. Then, in the early hours of the morning, Craig rushed into their quarters and shouted, 'Mam! Mam! Can you hear that?' Linda sat upright in bed, startled, and replied, 'Can I hear what?' Again Craig shouted, 'Listen!'

A South Shields family were terrified when a strange voice disturbed them during the night on an old canal boat. (Artistic representation)

By this time, Lonnie had woken up and all three listened in silence. It was then that they heard the voice, an intense female whisper repeating the words 'Look at me! Look at me!' By now, Craig was becoming scared and kept saying, 'Honestly mam, dad! Can you hear it?' 'We assured him that we could,' Linda told me, 'and immediately looked outside the boat for any intruders. None were found, and to be quite honest our dog would have barked straight away if there had been. Anyhow, during this time the voice never stopped whispering.'

As luck would have it, the couple had bought Craig a digital sound recorder for his birthday a few days previously, and they suggested that he try and record the mysterious voice. Craig dashed off, retrieved the recorder and, commendably, did indeed manage to record the strange voice.

Linda explained why she didn't think the sound could have had a natural explanation.

When mooring up and settling for the night, all the engines are switched off and the keys removed. There is no engine running, no central heating on... so it was silent both aboard and outside the boat. We had our dog with us, and during that night he seemed unsettled and he paced the floor back and forth as if he was guarding us all! I even got up and checked the windows to make sure they were secure and they were. There simply wasn't anyone around the boat, and we could still hear that strange voice whispering, 'Look at me! Look at me!'

Not wanting to frighten Craig any further, Lonnie and Linda made up an excuse for the sound, saying that it was probably just the water lapping against the side of the boat. When the family got back home after their vacation, they downloaded the recording onto the family's PC and boosted the volume. There was no doubt about it: the mystery voice had definitely been whispering, 'Look at me!'

The couple sent me a copy of the recording, and the fact is that they are telling the truth. Who, or what, was whispering to them that night we may never know. I later wrote up the story in my 'WraithScape' column and received a good response from readers.

FAERIES AND OTHER STRANGE ENTITIES

Fairies – properly called faeries – are part of our popular culture. Although only a handful of people would claim to still believe in them, the word 'fairy' creeps into our conversation more than we possibly realise. We talk of lies as 'fairy stories', romances as 'fairy tales' and people who have their heads in the clouds as being 'away with the fairies'.

Now, it may surprise readers to know that quite a few eminent people through the years have actually claimed to accept the existence of faeries as objectively real creatures. Among these was Sir Arthur Conan Doyle. Was Conan Doyle mad? Not really. To understand why, it is necessary to take a trip into the past to discover exactly where the belief in faeries originated.

The ancient Babylonians believed in faeries. The Vikings did to, as did the ancient Celts, although their appearance and alleged purpose changed from place to place. The faeries of old were not small, delicate creatures sporting gossamer-like wings. Some were of human height, others as small as a caterpillar. Some were called 'pig-ugly', whilst others were said to be so beautiful that you could be enchanted just by looking at them.

Nor were they always friendly. Faeries had a terrible reputation for swapping their own children with those belonging to human couples. These faery children, raised unwittingly by humans, were called changelings and were reckoned to have special powers. Some researchers have likened the faeries of old to the archetypal alien 'Grey' UFO occupants, and suggested that they are both manifestations of the same cultural icon.

Interestingly, there are strong parallels between faeries and aliens. Both are said to be small, have different coloured skin and large, almond-shaped eyes. Both are said to kidnap humans and spirit them away. Intriguingly, the faeries are said to be controlled by 'higher elemental spirits', whilst the alien Greys are said to be supervised and directed by a 'superior alien race' who use the Greys as slaves.

It's all riveting stuff, and much of it should be taken with a colossal dose of salt. However – Peter Pan to one side – Conan Doyle may not have been altogether off-beam when he suggested that faeries really do exist. You see, they may well represent our deepest hopes and fears, being manifestations of our subconscious mind. In short, faeries may 'exist' for no other reason than that we create them. Some Tibetans believe that 'thought-forms' (called *tulpas*) can be wished into existence. Those who see faeries, then, may actually be witnessing something formed within the depths of their own mind and manifested externally.

Some people start to doubt their sanity when they see a UFO. Others start to question their reason when confronted by a ghost. But what would you do if you woke up in the

A mysterious faery ring was spotted in South Shields by a local resident. (Artistic representation)

middle of the night and thought you could see a bunch of faeries dancing around in a circle right outside your house? One chap told me he did, actually, and although I can't vouch for his story he seemed sincere. Of all the various and sundry types of paranormal phenomena, a belief in faeries is one of the most bizarre. The very suggestion that small, winged humanoids dressed in tights and sprinkling stardust could have any sort of objective reality will normally be greeted with howls of laughter.

The aforementioned Sherlock Holmes author (and occasional *Shields Gazette* writer, would you believe) Sir Arthur Conan Doyle, like his fictional hero Holmes, was not averse to solving mysteries by accumulating circumstantial evidence. In his case, he came to believe in faeries after viewing some startling photographs of the 'wee folk' taken by two young girls. The photographs fooled the famous author and a bevy of eminent photographers, but, alas, most people now believe they were faked.

But there are other telltale signs that the little people may have been paying a visit. One of them is a very strange phenomenon known as the faerie ring. Faerie rings are, allegedly, the dark circles left on the grass after the faeries have danced there. University lecturer and folklore expert Stephen Swales told me,

> Traditionally, faerie rings are the meeting place of the earth spirits and may even be the dwelling place of the spirits of trees which stood there at one time. Such areas should be protected, as faerie rings are not common. I would hope that local environmentalists would investigate such sightings and find out exactly what type of natural phenomenon this is. Building on such sites is definitely not a good idea, as any structures erected over the rings will likely suffer from a lot of psychic disturbance.

Fantastic though all this might seem, you may be interested to know that a number of faerie rings have been found and photographed in South Shields by none other than

Bede's Well in Monkton Village, which is said to possess miraculous healing powers and is also said to be home to elemental spirits such as faeries.

our very own Dot Golightly! Dot noticed these rings near her home, in the Westoe area of South Shields: 'I was amazed to see them on the grass next to Glenthorpe House in Wawn Street. I didn't know whether to think "alien spaceships" or what!' Had the 'wee folk' been dancing there, then?

Alas, no. You see, there is a perfectly natural explanation for the phenomenon and it does not involve diminutive humanoids prancing around with wands and dressed in pointy shoes. Faerie rings are actually caused by a fungus that feeds on nutrients in the grass. When the nutrients run dry, the fungus moves outwards in search of more food, leaving a small circle behind it. As the fungus keeps moving outward in an effort to feed, the circle gets bigger. These mysterious hoops of darkened grass certainly look weird, so I'm not surprised that they were eventually labelled as faerie rings. Whatever the cause, let's hope they return next year and take their place on South Tyneside's rich and varied tapestry of folklore, myth and legend.

In times past faeries were said to inhabit several places in South Tyneside. Some of the glades that shadowed the River Don at Jarrow were said to be home to the 'wee folk', as was the vicinity of St Bede's Well in Monkton. It's known as Bede's Well, for it was there that the venerable scholar and monk allegedly sprung forth from his mother's womb. Inevitably, the well acquired a miraculous reputation. The vapours? Scrofula? Suffering from a touch of the humours? Visit Bede's Well and you'll be hunky-dory in no time. Or so the legend went. Now, the good thing about the cures realized at Bede's Well is that they were free. Well, almost free. A local superstition dictated that your sickness would be relieved only if you threw a bent pin into the sacred waters. Why, I know not, but the fact that loads of them have been dredged up over the years demonstrates that this bizarre form of treatment must have been deemed reasonably efficacious.

The Venerable Bede was one of our greatest scholars, and visitors to South Tyneside can still see the remains of the monastery where he worked, rested and prayed, all

without the help of a Mars Bar. Bede's greatest achievement was to invent our modern calendar by which we could date the year 2000, or the Millennium. Think of it: if it hadn't been for Bede, we wouldn't have had the Y2K fiasco which threatened to combust every computer in the universe at the stroke of midnight. Mind you, I don't want to sound petty, but strictly speaking the Millennium didn't really begin until one year later at the dawn of 2001, but let's not get sidetracked. Bede was a really clever dude, and that's that.

There's a chair in a nearby church that is said to have belonged to Bede and a number of miracles have been said to happen when people have sat upon it. Here's the problem though: Bede lived AD 673-735, but carbon dating tests have proved that the chair probably dates back to the ninth century. If sitting on the chair does precipitate miracles, they can't have anything to do with the good monk. The well, however, is a different story. Unfortunately, its history and reputation have been neglected terribly and few people know the true tale concerning its miraculous powers.

At one time the well was, well, a *well* – that is, a hole in the ground filled with water. However, over the centuries a succession of well-meaning officials from hither and thither tried to tart the hole up by surrounding it with fences, walls, paving stones, ornamental skirting and God knows what else. The idea was to make the well more visible and at least give the appearance that it was being revered as a historical monument, if not exactly the Geordie version of Lourdes. With every passing 'improvement', however, the aperture of the well became smaller and a steady stream of rubble and junk ended up in the hole.

Some years ago my wife and I visited Bede's Well and were appalled to find out that it has now dried up altogether. A large, paved precinct surrounds what is left, along with beer cans, crisp packets and other detritus that does not bear mention in a book that may be read by youngsters. That a historical landmark of such significance could be allowed to deteriorate to this degree is completely unacceptable.

But hang on a minute, we surely need to ask ourselves at this juncture whether or not the miracles associated with Bede's Well are really true. If not, then other than the fact that Bede was supposed to be born in that vicinity, this rather unassuming hole in the ground really hasn't much to brag about. But there *have* been miracles. During the nineteenth century, on Sunday mornings upwards of twenty children at a time used to be brought to the well to be immersed. Many, particularly those suffering from ague (a sudden and severe fever) found their symptoms reduced or even removed completely after the event. Even in recent years, before the well became polluted with rubbish and covered up completely, it was common for people to visit it and drink in an effort to cure an ailment.

Alas, it isn't possible to put the healing properties of Bede's Well to the test now, which is a shame. However, there have recently been a number of voices crying out for the landmark to be restored to its primitive but glorious appearance. I support this proposal firmly. It is said that the ghost of Bede has been seen at the well, and that the sound of a baby crying (Bede as a youngster?) has been heard after midnight. It's all a mystery, but an intriguing one. Me? I'd gladly pay three bent pins to anyone who can supply the answers.

Some locals put the healing properties of Bede's Well not down to the good scholar but to the presence of the 'wee folk'. The problem was that in times past the faeries and other elemental spirits had a terrible reputation for doing mischief

if the mood took them. One of the most common notions was that they would kidnap human babies and exchange them for their own children. As a child, I don't recall my parents ever being unduly worried about me being kidnapped. My father wasn't a wealthy businessman, my mother wasn't a film star and I wasn't – to put it mildly – the rosiest apple in the barrel. Not that any of these disadvantages would have troubled the faeries of South Tyneside, mind you, who, according to ancient lore, snatched human babies with cavalier abandon. Even ugly babies such as I, may I add.

The north of England seems to have been the favourite hunting ground of these diminutive kiddie pinchers, and in times past the good folk of Hexham and the surrounding environs developed a battery of sophisticated tricks to protect themselves – or more specifically their offspring – from their evil designs. The best defence against the faeries was believed to be baptism, and it was generally considered that if you could keep a baby out of the faeries' clutches until then, the child would be reasonably safe thereafter. The tricky bit was the safeguarding of the infant from the cutting of the umbilical cord until the baptism and hence special measures were called for.

Placing a bit of bread in the bottom of the cradle was a well-attested measure. Smart folk probably used Greggs' stotties, which, I am told, were efficacious against ninety-nine per cent of all known faeries. Mind you, a Warburtons' thick sliced would probably be just as effective, provided it wasn't past its sell-by date. Then again, you could always try salt. Or garlic. Fair enough, your young 'un may possess an aroma not unlike that of a ripe Italian salad, but at least the faeries would keep their distance – along with everyone else, I imagine. Another trick was to leave a sharp knife, sewing needle or pin in the cot. All of these items had to be made of iron, a substance that apparently has an extremely negative effect on faeries, elves and other denizens of the twilight dimension. My worry would be the negative effect such dangerous artefacts would have on the child if they punctured themselves. Maybe the bairns' feet were placed in coal scuttles – who knows?

Now if all the above measures fail, and the 'wee folk' are still trying to whisk away your newborn, fear not. Simply sequester from the father a working boot – one that has been worn for seven consecutive days, mind you – and place it next to the child. Lo, the faeries will run a mile and never trouble the babbie again. It's true, I swear. For added protection, swap the father's boot for a year-old trainer that was previously owned by a permanently perspiring teenager. Just remember to supply the baby with a gas mask and high-grade chemical protection suit, otherwise it may melt or spontaneously combust. This may result in you being asked awkward questions by the local constabulary, who take reports of melting children very seriously, I believe.

Oh, I'm jesting, of course, but it is indeed true that faeries were believed to kidnap newborn babies, and the above-mentioned protective rituals were carried out in all seriousness. Cynics may laugh and mock such notions now, but perhaps we need to be cautious. Rituals are important in every culture. We still throw spilt salt over our shoulders, refuse to place new shoes on a table and cross our fingers to avoid bad luck don't we? None of these measures are more logical than the quaint baby-protecting measures employed by our ancestors, so perhaps a bit more respect is required – both for the curious ways of our forefathers and the 'wee folk' who, for all I know, still inhabit the more remote areas of our beautiful countryside.

Marsden Bay – allegedly home to faeries and other elemental spirits.

Another faerie hot spot was Marsden Bay at South Shields, where the 'wee folk' were believed to live in a cave called the Faerie's Kettle. They were said to be absolutely ferocious if you tried to pinch anything from them.

NATURE SAYING THANK YOU

City life doesn't suit everyone. Sure, there are advantages. These include an overwhelming choice of stores to shop at, public transport and access to all sorts of amenities unavailable to country folk. However, there is a downside to being a townie. As a society we have largely lost the ability to communicate with the natural world around us. For many, the countryside is simply somewhere to visit on bank holidays, foot-and-mouth disease not withstanding.

But it wasn't always like that. The ancient Britons, for example, had great respect for the natural world, as did the Celts. To these tribal people the forests were places of wonder, inhabited by all manner of elemental spirit-deities who had to be respected. Whether such deities actually existed, of course, is another issue, but the point is that the spiritual beliefs of ancient tribal peoples made them treat the world with reverence.

Some time ago a South Shields reader told me of a strange experience he once had whilst walking in an area of rural tranquillity. His journey had led him to a crossroads, and a quick check of his map indicated that he should go straight ahead. But he did not. Instead, he turned right and headed towards a heavily wooded area, which, for some unknown reason, had drawn his attention. On entering the wood the man heard a rustling sound. He walked in the direction of the noise and found a bird, which was trapped. Somehow its foot had become entangled in the handle of a plastic carrier bag which had been carelessly discarded there. Gently, the man picked up the bird and

A South Shields woman encountered a number of strange creatures in a local park.

disentangled it. He then let it go and watched it soar into the sky, free again. He then decided to return to the crossroads and resume his walk.

There was, however, a strange twist to this tale. As he retraced his steps the man stumbled upon a huge circle of wild mushrooms. 'I'm sure they weren't there when I passed by the first time,' he said, 'I would have seen them.' Something told him that he should pick the mushrooms, which looked very appetising. The next day, at work, he happened to mention his experience to a colleague who had considerable farming knowledge. 'Nothing strange about that,' he said. 'It's just the forest's way of paying you back for helping out that poor bird.'

The more the man thought about this the more he liked the idea. However, he found the notion that the woods themselves possessed any kind of sentience or consciousness absolutely preposterous. Nevertheless, many people have reported strange sensations and feelings in wooded areas, as if they were being watched. Sometimes these feelings may be pleasant, other times not so. Several letters have been published in the *Fortean Times* from readers who suddenly felt compelled to remove themselves as quickly as possible from a particular area, as if they were not welcome there at that particular time. I should point out that these strange experiences have happened to doctors, lawyers and fire fighters, not just hippies and New Agers.

The bottom line is that the world is a strange and mysterious place which we will never fully understand. I learnt a long time ago never to pour scorn on ideas which seem silly, for a good number of them inevitably turn out to be valid.

PIXIE-LED

There is an old legend that if you stray into the territory of the 'little people' you can become 'pixie-led'. The story goes that pixies can toy with humans by making them go

round in circles. The solution, it was said, was to turn your jacket inside out. For some reason this would break the spell.

In March 2001, a reader of my 'WraithScape' column told me of her own experience. Susan* recalled the time when she'd been walking through a local park, early one summer evening, when she thought she saw something move on the path up ahead of her. 'It was fleeting... it moved so quickly across the path that I didn't have time to focus on it. I thought it must have been a mouse or a rat, but then I saw more of them. It's hard to describe what they looked like... they were just like shimmers of light at ground level. What made me think there was something odd about them was the way in which they always shot across the path from left to right – never the other way.'

As Susan continued walking, she admitted that strange thoughts continued to enter her head. 'I started to feel guilty about things I'd done in the past... about lies I'd told, bad things I'd done to people. There were other things in my life that I was ashamed of too, and to be honest I don't want them mentioned. I hadn't led a very moral life, to put it mildly. People I knew used to call me 'Miss Horizontal' behind my back, which should give you a clue. For some reason all these things started flooding in to my head as I saw these shimmers of light cross the path.'

Then Susan noticed something else. Although she'd walked that path many, many times she suddenly realised that she didn't know where she was and her surroundings all felt unfamiliar to her. 'I felt that all these eyes were focusing on me from within the bushes. It was as if they knew about my past and were condemning me, accusing me. I just kept on walking and walking, and it seemed to take ages but eventually I got to the top of the park.'

'The next morning I rang my friend and told her what had happened. She said I'd been pixie-led and needed to make up for my mistakes. She'd made quite a few of her own, I can tell you, so I put the 'phone down on her. This was a stupid thing to do, but I was very arrogant. Later that day I found a lump on my back and went to the doctor. It was skin cancer. I was treated for it but I still have to have check-ups. To this day I believe those things, whatever they were, cursed me for being so nasty.' There could, of course, be more prosaic explanations. Certain illnesses can make those who suffer from them disorientated, whilst stress and tiredness may also play a part. However, not all cases are as easily explained away.

Quantum physics has taught us how weird the universe really is. The old idea that time is 'linear' and neatly packaged into past, present and future, has now been almost universally abandoned. The relationship between time and space has also had to be rethought. There is a real possibility that certain conditions can allow physical principles such as time, space, matter, force and motion to become distorted. Anyone caught up in such a distortion could experience all manner of bizarre phenomena, the cases above being a classic example. Some researchers believe that such anomalies are caused when we accidentally slip into another dimension, a world which is broadly similar to our own, but not identical. Whatever the truth, there is one thing that Susan knows for certain: she'll never walk through that park again on her own.

CHAPTER 8

GHOSTS, HAUNTINGS AND APPARITIONS

Some time ago I was enjoying a pint in the Alum Ale House, just off South Shields' Market Square, when I bumped into an old friend of mine who, for the purposes of this story, prefers to remain anonymous. I'll simply refer to him as J.

J told me that a good few years ago he was employed as a bar manager in the bingo hall, which previously had been the old Odeon cinema in King Street, South Shields. Cinemas and theatres – as well as bingo halls, I might add – have a well-deserved reputation for being the lair of ghosts and spirits. The old Odeon was certainly no exception. Several members of staff who worked at the premises reported feeling a 'presence' in the stalls, both during the Odeon's days as a cinema and as a bingo hall. On one occasion a member of staff opened up the building and saw a lady in a grey dress 'glide up the aisle' before vanishing into the ether. As the chap in question had secured the premises the night before, after checking the building thoroughly, he knew for certain that no one had been locked in there accidentally.

J's story was even more interesting. One day, a fellow employee had approached him in a state of great anxiety. According to J, he was so upset he could hardly talk. With a trembling hand he pointed towards the main hall and J, puzzled, accompanied him in an effort to find out what was wrong. Now, it so happened that in the hall was a large organ, which had been sitting there, unused, since the old silent movie days. Decades earlier it had been disconnected from the electricity supply, and bits of the internal wiring had also been removed. Essentially, the organ was incapable of working. Despite the fact that the organ was not connected to the electricity supply, to all intents and purposes it appeared to have been switched on, and its decorative lights filled the hall with an eerie glow. At this point J assumed that he was being set up as the victim of a practical joke. However, this notion was soon to be dissipated.

Firstly, his colleague was obviously quite traumatised. J could tell by his reaction that he wasn't 'putting it on'. Secondly, as J inspected the organ he could see with his own eyes that no electricity was being fed into the machine whatsoever. At this point, discretion got the better part of valour and they both ran out as fast as their legs could carry them.

Since interviewing J I have interviewed several ex-employees of the bingo hall. They unanimously agreed that certain areas of the building had an 'eerie' feel to them. One woman, a former cleaner, said that objects would 'move around without anyone touching them'. Another said that she had heard the organ playing when it was definitely disconnected.

There is no doubt in my mind that the Odeon was haunted, but personally I don't believe that all ghosts are conscious entities. Rather, some are merely images from the past which are somehow transported through time and displayed in the present. This doesn't explain how the disconnected organ burst into life, however, and I'd love to know who the lady in the long, grey dress was.

THE HAUNTED COMPUTER

There is a convention in the field of paranormal research that investigators should start off by believing nothing, but be prepared to believe anything. Let me tell you, this is true.

During my years of investigation, I have heard stories that make 'conventional' mysteries such as the Loch Ness monster and the ghosts that haunt the Tower of London look positively boring in comparison. Now that we're in the twenty-first century, it seems that even the field of Information Technology isn't immune to spooky goings-on; a number of tales are currently being circulated on the Internet about allegedly haunted computers.

One story concerns a man who switched on his PC to do some word processing and suddenly saw a sentence appear on the page that read, 'Hi, I like your shirt! Please answer!' Initially he was convinced that some miscreant had infected his machine with a virus, but then he decided to play along. 'What colour is it?' he typed. 'Red and blue cheques, stupid!' said the mystery communicator. This apparently chilled the man to the bone, as he was indeed wearing a red and blue chequered shirt. Further dialogue then took place, during which the writer gave other details about the man that could not have been known unless he was actually in the room at the time.

Another story concerns Jeanne Stewart, a supermarket assistant formerly from Simonside, who kept getting mystery messages via her screen-saver. 'Before I moved to Simonside I'd had a number of strange experiences in my life. I used to work in Libya, and a number of times I thought I saw ghosts in my apartment. After I moved back to the UK nothing else happened until I lived in South Shields. For a while I worked in a car salesroom and that was when the thing with the computer happened.' One day, as Jeanne sat at her desk, the words 'Check your faucets' appeared on the monitor of her computer just as the screen-saver kicked in. A joke? She thought so until she arrived home and found that her husband had called a plumber to deal with a tap that was gushing water in the kitchen. The puzzling thing was why the word 'faucet' was used. This is an Americanism, and in Britain we nearly always use the word 'tap' instead. Regardless, Jeanne is convinced that the message on her screen-saver and the plumbing problem at her home were not unconnected. Jeanne later moved to Derbyshire, and to the best of my knowledge has had no further paranormal encounters – on or off the computer.

What are we to make of such tales? In some ways they are reminiscent of old science fiction novels from the 1950s, in which super-intelligent computers took over the world. Could your PC really be developing a mind of its own? Well, I doubt it, but then again I can also remember another story – hopefully fictional – in which all the computers in the world joined together and declared war on humanity. Seriously though, I think that at least in some cases the only logical explanation may well be a paranormal one. Maybe discarnate beings are using computers as a means of communicating with us, which is fine as long as they've got something of reasonable import to discuss, and not just the colour of our shirts and the state of our plumbing.

One man was startled to find that an invisible entity started to talk to him via his computer. (Artistic representation)

HAUNTED PEOPLE

Some time ago I received a number of letters from Dorothy Elliott, who has had several spectral encounters over the years. So many, in fact, that I started to wonder whether *people* can be haunted as well as places. Dorothy is a delightful person, and I have no doubt that she is totally sincere in recounting her experiences, but how can we explain the fact that one person can be subjected to so many supernatural events? My personal view is that a percentage of the population may be 'tuned in' to the spectral world and find it easier than others to see things that the rest of us simply miss.

Dorothy tells me that several years ago she was holidaying in a very old country cottage with her husband when she had a truly weird supernatural encounter. Suddenly, she was confronted by an old man who was playing the fiddle. This struck Dorothy as odd, and the following morning she happened to mention the incident to the lady who lived in the cottage next door. Without further ado she went inside and returned moments later with an old photograph of a group of people and asked if Dorothy recognised the man she'd seen the day before. She did. There he was in the picture, as large as life. The man had inhabited the cottage Dorothy was staying in many years ago, the woman said, and he had loved to play the fiddle. Nothing strange up to this point, you might think. Perhaps the man had just decided to pay his old abode a visit for sentimental reasons. Well, maybe. The problem was that he had died several years earlier.

Dorothy had another ghostly encounter just recently whilst staying at an old hotel in Carlisle. Whilst sitting near the foot of the staircase she felt 'strangely alone' and, simultaneously, was aware of someone behind her. She turned to see a handsome young man in Victorian clothing descending the steps and sensed that she was seeing an apparition. At this point Dorothy's husband spoke to her and her attention was

A Monkton man saw the ghost of a Victorian woman descend a stairwell in South Shields. (Artistic representation)

distracted for a split second. When she turned the man had gone. The strange thing was that Dorothy did not feel afraid of the ghost. In fact she says she felt comforted by its presence. This is a common experience with many hauntings. Incidentally, a Monkton man also saw a Victorian woman – or her ghost – descending a stairwell in South Shields.

On another occasion, whilst staying in Scotland, Dorothy saw the ghost of a small child jumping about from chair to chair and really enjoying herself. She was oblivious to everyone there, although Dorothy does not say whether the spectre was only visible to her or to the other guests as well. Dorothy said that the girl's clothing indicated that she had lived during the 1940s.

But not all of Dorothy's encounters have been pleasant. Once she was on vacation in a hotel in northern Spain when she happened to go into the guest lounge. Sitting on her own was a lady dressed in black, old-fashioned Spanish style clothing. Something told Dorothy that she was the owner's mother but she couldn't explain this to the owner later as he didn't speak English. She also had a powerful feeling that the elderly woman resented her presence, as if she had no right to be there.

Dorothy Elliott seems particularly sensitive to the apparitions that haunt older buildings, including castles. 'My visit to Chillingham Castle was the worst', she says. 'I wouldn't fancy staying there overnight, even with company!' Dorothy also felt uncomfortable whilst visiting Muncaster Castle. She didn't actually see anything but felt that the place had a bad aura.

Although some people would feel almost cursed by the repeated appearance of ghosts, I actually believe that Dorothy is lucky. Her gift enables her to catch glimpses of another world that is very different to our own and one which, in the fullness of time, we may all be destined to visit.

CHAPTER 9

HIDDEN WORLDS, STRANGE DIMENSIONS

Several years ago, popular music fans and sci-fi buffs alike were enthralled by the song 'Cartoon Heroes' by the group Aqua. Both the lyrics and the excellent video captured perfectly a bygone age – the mid 1930s to the early 1960s – when pulp science fiction had its own distinctive character. *Dan Dare, Amazing Stories, The Twilight Zone* and *The Outer Limits* – we'll never see their like again, and we are the less for their passing.

One of the most popular themes with early science fiction writers was that of alternate dimensions, twilight realms that housed all manner of strange creatures and dastardly space villains. 'B' movies like *The Creature From The Fifth Dimension* and awful novels such as *They Came From Dimension Ten* may not have been award-winning stuff, but they thrilled legions of bored citizens who had no other means of indulging their desire for absolute escapism.

But could there *really* be other dimensions – perhaps even entire universes – that exist alongside our own? Is it possible that other realities truly exist, strange worlds on another plane that we are entirely ignorant of? And what of the lost cities of fable and legend? Is it possible that they too might truly exist in the remoter and unexplored regions of our planet? Read on, and decide for yourself.

TOM JADZ AND THE ARCHWAY TO ANOTHER WORLD

In recent years, advances in quantum physics theory have demonstrated that our world, and the universe as a whole, is a far stranger place than we ever gave it credit for. We now know that time, for instance, doesn't really flow in the simple past/present/future linear stream that we hitherto imagined, and that under certain conditions matter can be made to react in bizarre ways which almost defy logic.

We cannot, then, rule out the possibility that other dimensions exist. Because their physical reality may be entirely different from ours, 'our' dimension and 'theirs' may actually be in the same geographical location, but operating on a different 'wavelength', so to speak. It is strange to think that there may be another world existing alongside our own which we can neither touch, hear nor see – at least, not usually.

One reader told a reporter and I of a strange experience he had when he was a young boy of ten. He was sitting in the back garden of his home. It was a beautiful summer's day and the sun was shining brightly. At the top of the back garden was a trellis and an archway covered in ivy and other climbing plants. Suddenly, the trellis arch began

to shimmer like heat coming off a hot road. Then the shimmering stopped, and he was astonished to see that the view through the archway had changed completely. Instead of houses across the road, Tom Jadz could now see rolling hills and forests. 'I was shocked, as you can imagine,' he recounted, 'I could see trees, but they were strange trees like none I've ever seen before or since. They were like palm trees, but they had large, orange globes stuck to the trunk in a circle about eighteen inches from the ground. In fact, all the plants seemed strange.' This strange vision only lasted for about fifteen seconds. Then the archway shimmered again and everything went back to normal.

The witness swears that this bizarre experience really happened. Although he was frightened, he never told his parents. 'They were not the understanding sort,' he confided. He was also careful to avoid going through that arch again, frightened that something might happen and he would never come back.

Was this simply a vision of the remote past? A glimpse of how this area once appeared in primeval times? Or did this youngster catch sight of another dimension entirely, one that holds unseen wonders and opportunities if only we could find a way to explore it?

This was not the only strange experience that Tom had, as we shall see presently.

DISTANT WORLDS IN TIME AND SPACE

On more than one occasion I've written about 'other dimensions' – that is, worlds that are as real as the one we live in but which exist on a different plane of reality. As the previous story illustrates, from time to time a number of people have claimed to visit these other dimensions, returning with fantastic tales beyond the wildest stretches of the imagination.

But what about other worlds *within* this universe? Is it possible that portals exist that could allow us to travel to far-flung regions of the galaxy instantaneously? Programmes such as *Stargate* – oft repeated on Sky TV – certainly suggest so.

And then there's the matter of black holes, those centres of supergravity that suck anything and everything in before expelling the same material, in a rather compressed form, somewhere else. One theory is that black holes could actually be used as shortcuts to take us from one part of the universe to another in the blink of an eye. How on earth we're supposed to survive the gravitational pressure – which can condense something as big as planet earth to the size of pea – no one seems to have worked out.

Despite the logistical difficulties, a number of UFO abductees claim to have visited other planets – other solar systems, even – courtesy of extraterrestrials who have allegedly taken them there, in a flying saucer, when they had an hour or two to spare.

But here's the real problem. Satellite and probe photographs have demonstrated that the bleak terrains of the planets in our solar system are nothing like the way many abductees describe them. The moon, according to one famous 1950s UFO buff, was, at least on its dark side, covered with forests and all manner of strange flora and fauna. One nineteenth-century religious leader even said that the moon was populated by 8ft tall humans who wore top hats. If true, then Neil Armstrong, Buzz Aldrin and others don't seem to have bumped into them – or if they did, they aren't telling.

Seriously though, we cannot discount the possibility that life does exist on other worlds. Many ancient traditions – such as those of Native Americans – speak of 'sky people' who came from the stars many millennia ago. If they visited us on our home world, then they surely must have one of their own.

Some Native American peoples believe that in ancient times we were visited by creatures from other worlds. (Artistic representation)

Perhaps the most fascinating tales come from those who claim to have visited other worlds in their sleep. One correspondent told me that the same landscape kept appearing every time in her dreams: a hot, dry desert with pale blue sand and a purple-tinged sky. What convinced this lady that she was really travelling to this place in her sleep was the fact that, whenever she had this dream she would wake up and find grains of sand and dust in her bed and adhering to her nightclothes. Alas, she did not keep these particles for analysis.

If science ever does find a way of travelling to other worlds quickly and easily – an almost impossible task, some would say – the potential would be beyond our imagination. Imagine what it would be like to be the first human to set foot on a planet at the other end of the galaxy, or the first person to dive into an ocean on a world thousands of light years away.

We can but wonder. Meanwhile, perhaps we should continue watching *Stargate, Star Trek* and even – dare I say it – the wincingly awful re-runs of those black-and-white episodes of *Dr Who*.

PHIL TOOMEY'S MYSTERY STONE

Phil Toomey is someone who, until May 2003, didn't believe in 'weird stuff', as he put it. All that changed, however, when a bizarre experience convinced him that there was more to this strange universe of ours than meets the eye.

Phil had been working hard for several weeks, transforming his back garden, which was, by his own admission, an absolute tip, into a little patch of Eden. 'At the very top of the garden was a patch of soil and mud that hadn't been touched for years. I decided

to fence it off and grow vegetables on it. The trouble was that the ground was full of stones, old house bricks and other bits of junk. I knew I had to dig the patch over first.' And this was where things started to take a strange turn, so to speak. When Phil dug his spade into the earth there was a jarring 'clang', and he knew he'd hit either a rock or a brick. Plunging his hand into the soil, his fingers made contact with the offending object. He pulled it out. 'It was a lump of sandstone, actually,' Phil told me, 'about the size and shape of a dinner plate and roughly an inch thick.' Phil pulled the stone from the ground and looked at it. 'As soon as I touched it I had a really strange feeling. I can't explain it, other than to say that I felt the stone was special in some way.'

Phil buried the stone at the side of the new vegetable patch. It just seemed like the right thing to do, he told me. Then he then got on with the job of digging over the rest of the soil. The next day – it was a Sunday, Phil remembers – he made a conscious decision to finish off the garden even though the weather was none too clement. After breakfast he donned his gardening togs and ventured outside. The sight that met his eyes was not what he expected. Lying on the path, right next to the back door, was the stone he'd dug out of the vegetable patch the day before. 'How it got there I don't know,' Phil told me, 'because there's a high fence around the garden and there was no sign of intruders. Anyway, who would want to break into my garden just to move a piece of stone?'

Another thing struck Phil as odd. He recalls that the stone was perfectly clean, without so much as a speck of soil. 'It looked like someone had scrubbed it clean before placing it on the path,' He said. Phil thinks that the stone had been used in a building hundreds, if not thousands, of years ago. 'I don't know why I think that... it's just a hunch,' he added.

Phil still gets a strange, tingling feeling whenever he touches the stone, which now stands next to the back door of his home where he found it. Where did it come from? No one knows. And why does it emit such a strange aura?

Phil later developed a theory that by touching the stone he was in some way connecting with a lost civilisation that had crumbled into the dust thousands of years ago. Who knows, he may be right.

SPACED-OUT DREAMS AND NIGHTMARES

The aforementioned Tom Jadz of Primrose, Jarrow, told me a fascinating story about a dream he had which reoccurred over and over for a period of several months during the year 2000. In fact, the dream was so intense that Tom is convinced it wasn't really a dream at all but rather a vision of the future.

> Usually it would start in the same way. I'd be in a spacesuit, peering out through the visor, with air being pumped into the suit from a unit in my backpack, but it was extremely hot and clammy. In front of me would be a vast landscape of red rocks and mountains. I knew I was on Mars. Just to my left and slightly behind me was another astronaut. I remember him talking to me. On one occasion he said, 'Come on – you know how easy they get stirred up after dark. The folks down below will go ape if we have to use the HIL, and we can't white-light them in case someone sees us.' The last thing I remember is quickly walking back to the living module feeling very apprehensive.

A Primrose man had a vision in which he dreamt he visited the planet Mars as an astronaut. (Artistic representation)

Tom says that during these visions everything made sense, but after waking he hadn't a clue what much of it meant. Who (or what) were 'they' that got stirred up after dark? What was a 'HIL', and how on earth do you 'white-light' somebody?

On another occasion Tom remembers having a conversation with a NASA official over the radio. 'He was called George, and he was alarmed. I remember him shouting, "Evac! Evac! Get that line out of there and shut that thing down before they see it!" What it all meant I don't know.'

Even I'd have to admit that Tom's dreams were bizarre, but if he wasn't dreaming, could he have had a chilling premonition of man's first trip to the Red Planet? If so, it seems that we weren't exactly welcome there.

Interestingly, premonitions of this sort – if indeed they were premonitions – can sometimes be tested. We know that the USA plans to send a manned expedition to Mars within the next two decades. Could there be a 'George' already working for NASA on the Mars project? Do the terms 'HIL', 'white-light' and 'Evac' mean anything in astronautical parlance? If so, then Tom's dream may actually have some credibility. Mind you, a search of the official NASA thesaurus and dictionary of terminology revealed nothing.

Tom says that the dreams stopped as suddenly as they started. He has no idea what they meant, but he is convinced that they were 'real' – that is, not something dreamed up by an over-active imagination. 'I only wish I could have retained the knowledge I had when I was actually dreaming,' he said, 'but it never happened. During my dreams I was an astronaut. I understood the terminology used and everything. But, when I woke up, it would just fade away.'

I happened to have a reporter with me when I interviewed Tom, and we both told him that his account sounded like a poorly-written script from a low-budget science fiction film, and to our surprise he agreed. 'Tell me about it!' he exclaimed. 'Have you any idea

how embarrassing it is for me to tell you all this? But it's the truth – that's what actually happened in my dream!'

Make of it what you will, but there was a ring of sincerity about Tom's account that made us both believe he was telling the truth.

INTO THE FOURTH DIMENSION

Most readers will have seen those wonderful old black-and-white re-runs of *The Outer Limits and The Twilight Zone* on TV. Some may even remember those equally as wonderful comic books – also in black-and-white – with epithets such as *Creepy Worlds*, *Weird Tales* and *Astounding Stories*.

Back in the 1960s, no self-respecting science-fiction story or movie failed to make mention of that mysterious netherworld known as the fourth dimension. The fourth dimension was, according to popular wisdom, the home of flying saucers, the repository of faeries and the happy hunting ground of the Loch Ness monster to boot.

With all this talk about a fourth dimension, then, it would make sense at this juncture to ask an obvious question: could such a place exist? We live in a three-dimensional world. We think of things, and formulate our perspective of them, in terms of width, height and depth. If there is indeed a fourth dimension, then, it is unlikely to be a 'place', but rather another means of quantifying things that we are currently unaware of.

Because of this, philosophers now prefer to talk not about 'other dimensions' but rather of 'alternate realities', other worlds which may be parallel to our own but are invisible to us.

If such worlds exist, what might they be like? The short answer is that we do not know, because the laws of physics that govern our world may not apply in others. We may find that the fourth dimension, if it exists, is an alien landscape. It may be teeming with alien life forms, or, alternatively, be a barren wilderness similar to the surface of Mars or Pluto.

Over the years there have been thousands of mysterious disappearances recorded. Men, women and children of all ages and backgrounds have, seemingly quite literally, disappeared off the face of the earth. Could these people have accidentally wandered through a portal of some kind, a doorway into an 'alternate reality'? Did this doorway then close, trapping them there forever?

There is an old Jewish legend about a man who falls asleep in a cave whilst picking figs. He wakes up and, finding that it is getting dark, makes his way home. On his arrival he is astonished to find a stranger living in his house. He protests, only to be told that everyone he knew had died decades previously. It was as if he had been in a state of suspended animation for years, or at least living in a place where the flow of time was slower. In his basket the bewildered man still had branches of fresh figs. This convinced the other man that he was telling the truth, because the fig-harvesting season had finished months previously.

Where had he been all those years? Trapped in another world, a different reality? We can but wonder.

OF AEROCARS AND RAINBOW SUITS

The year is 2057, and you are a tourist visiting, say, South Shields for the first time. At the top of Fowler Street you guide your aerocar into one of the parking bays attached

to an overhead gantry and step out onto a small, circular platform. This anti-gravity device slowly lowers you to the ground, where a moving conveyor belt meets your eyes. You step onto this perambulating pavement which carries you towards King Street. You are surrounded by hundreds of happy, smiling commuters and shoppers. No one goes to work any more, as all labour is carried out by robots and artificially intelligent drones. Disease is a thing of the past, and the average human lifespan is now 250 years.

Welcome to the year 2057. Welcome to the Brave New World of the future. Well, the average town in the year 2057 *may* look like this, providing that some of our social commentators, scientists and prognosticators get their predictions right. Unfortunately, they have an appalling track record.

Back in the early twentieth century, films such as *Metropolis* and *Flash Gordon* provided an idealised picture of future life on earth, even if in outer space legions of space cadets were constantly having to fight off hordes of bug-eyed monsters from the Planet X. Jumping on the popular bandwagon, 'experts' began to predict what life would really be like in the future.

In 1961, one American writer predicted that within twenty years eating food would be a thing of the past and that everyone would simply have to swallow a 'nutrition pill' every morning. During the late 1970s and early 1980s the prognostications and prophecies became doom-laden and a growing number of writers painted an apocalyptic future which was depressing in the extreme.

Other tomes, some dealing with the prophecies of Nostradamus, presented visions of global warfare and atomic destruction, which is just what you want to hear after a bad day at the office. By the 1980s, even famous authors like Charles Berlitz were having a go. In his book *Doomsday 1999*[1], Berlitz drew together an impressive body of evidence which proved conclusively to many that the penultimate year of the twentieth century would, unless we took drastic action, be filled with catastrophe. But the end of the world didn't come anyway, and, once again, thoughts turned to inventing crazy gadgets to excite our humdrum lives. What would we have done without Furbies, bagless vacuums, Tamagotchis and socks with a built-in deodoriser?

Mind you, this isn't the first time that technology has been employed in such a manner. Back in the 1950s, labour-saving devices became an obsession. Besides food blenders, dishwashers and toasters, mankind was also blessed with the tie press, the battery-operated earwax remover, the magnetic window cleaner and a pocket-sized machine for buffing up your spectacle lenses. And perhaps the most bizarre was the late but unlamented Rainbow Suit. This was a natty outfit that would change colour when sprayed with a supposedly safe chemical. No one makes rainbow suits now. How on earth do we manage without them?

Perhaps the safest thing we can say about the future is that none of us really know what it will be like in any detail. Alas, we can but speculate. Some, however, may catch the odd glimpse.

1. Berlitz, Charles, *Doomsday 1999* (Souvenir Press, 1981)

HISTORICAL MYSTERIES

Some time ago I wrote an article for my 'WraithScape' column on the mysterious history of the Marsden Grotto inn, the only public house in the United Kingdom – as far as I am aware – to be built into a cliff face.

The article was well received, and several readers suggested that I should cover other mysteries connected with the Marsden Bay area. Perhaps one of the strangest of these is the succession of hermits who have taken up residence in the cliffs from time to time. The legends and tales of the Marsden hermits have become entangled and confused over the centuries, and disentangling them was quite a job.

The family of the nineteenth-century South Shields taxidermist William Yellowly seem to have been unusually knowledgeable regarding some of the characters that have lived at Marsden Bay. Yellowly's grandfather knew Blaster Jack who was one of the first people to live on the site of what is now the Marsden Grotto. Yellowly himself knew Peter Allan, the man who turned the Grotto into a public house, and, according to Yellowly's own testimony, his uncles were acquainted with another, infinitely stranger, person called William (or Willie) the Rover.

What we know about the Rover is scarce, but we can date his arrival at South Shields to approximately 1817. Yellowly's account of the Rover is found in the *Monthly Chronicle* of May 1887. He states that he inhabited one of the caves near Marsden 'between sixty and seventy years ago'. This would place his arrival at *c.*1817 and his departure at *c.*1827.

No one knew where William had came from, but he lived in a cave at Frenchman's Bay. Every day he would walk to Marsden Bay and make a few coppers by fixing the shoes of the local farmers and fishermen. To call him a cobbler is probably overstating things.

Willie had some strange habits. He would sit on a rock, gazing out to sea, and tell the fortunes of those who passed by. Some said that he was waiting for the return of ghostly sailors – comrades who had been lost at sea.

Willie subsisted by living off the land. Of an evening he would pinch a few mussels from the fishermen's 'bait baskets', which were kept underwater and contained live bait. He was also not averse to relieving the local farmers on the cliff top of the odd turnip or potato, but they turned a blind eye to his activities as he was, they believed, just a harmless eccentric.

William's dress sense was, to say the least, peculiar. He wore a knee-length tunic fashioned from animal skins – mostly rabbit – leggings to match, sandals and a small leather skullcap which one contemporary said gave him 'an appearance of one of the Hebrews'. Just before his departure from the Frenchman's Bay/Marsden area, rumours started to circulate that William was no longer satisfied with pinching the odd turnip or handful of mussels. It was alleged that he was now rustling sheep. Personally, I find this hard to believe, but the farmers believed it and decided to run Willie the Rover out of town.

The mysterious Marsden Grotto Inn, which has played host to a succession of strange mystics over the centuries.

Before they could do this, however, a strange thing happened. Willie turned up at the Highlander public house in Whitburn and announced that he was going to London the very next day to receive a fortune he'd inherited from a very rich relative. When asked how he intended to get to London he stated, 'I will walk, Sir'.

The next day, William the Rover started walking but in a northerly direction towards South Shields. So where was he going if not London? No one knows for sure, but if any readers can fill in the missing pieces of the jigsaw then I'd love to hear from them.

'BETTY HERON'S PALINGS'

Several years ago a reader from Seafield Terrace in South Shields asked me why I'd never written anything about 'Betty Heron's Palings'. Well, the short answer is that I'd never heard of the 'palings' in question, or indeed Betty Heron herself. The lady then told me what she knew, and I was fascinated.

Elizabeth 'Betty' Heron was something of a character, apparently being related to the wealthy nineteenth-century South Shields shipping magnate Sir Cuthbert Heron. Sir Cuthbert did in fact have a daughter called Elizabeth, although it is highly unlikely that they are one and the same person. Sir Cuthbert's daughter was a lady of grace and social standing. Our Betty Heron was slightly less refined, shall we say.

Betty lived in a cottage near to where the north-west entrance to the South Marine Park now looks out onto Ocean Road. The locals were slightly suspicious of her, although she had gained something of a reputation as a wise woman. Betty also kept goats. I don't know what breed they were, but by all accounts they had a psychopathic quality which made

65

Betty Heron's cottage, where a mysterious downpour of blood fell from the skies. (Artistic representation)

them want to kill everyone who came near them. Betty herself often got on the wrong side of her pets, and on more than one occasion had to be carted off to the infirmary in a serious condition after they turned on her. Nevertheless, she always seemed to recover.

Betty earned her living in several ways. She took in washing – a popular 'guvvy job' back then – rented out small boats to pleasure trippers and also sold ginger beer and sweet cakes to passers-by.

Always one to buck tradition if she felt like it, Betty did a large wash for a neighbour one Good Friday and hung the clothes around the picket fence or 'palings' which surrounded her cottage. This bothered her more pious neighbours who said that no good would come of it. Working on a Good Friday in those days was tantamount to dancing with the Devil himself. Betty ignored their comments and got on with her chores.

Several hours later Betty ventured outside to check the washing and see if it was dry. To her horror she noticed that huge splashes of blood were covering the clothes and sheets, and there seemed to be no natural explanation as to how they had got there. Betty's neighbours knew, of course. This was a sign from the Almighty that she shouldn't have worked on a Good Friday.

I have another theory. The famous South Shields naturalist William Yellowly once remarked, 'I have frequently seen the ravens in early morning sailing in graceful circles at a great altitude above their nests; and once I saw a pair of these sable marauders each carry away a gosling as large as a partridge, which they bore away to their young in the cliffs. I was informed by my uncles that they not only lost chickens and goslings, but frequently had young lambs killed by these voracious birds. During the lambing season the ravens would sit near the ewes, croaking the while; and if the opportunity arose they would at once seize and carry off the new-born lamb. And sickly and dying sheep would have their eyes picked out by the same birds.'

Bear in mind that the seagulls which we now see in their hordes did not completely dominate the coast then, in fact the ravens did. At the time I concluded that there had probably been a fight of sorts above Betty's cottage between two birds and the blood that was spilt during the carnage ended up over the freshly washed clothes. (Mind you, it's possible that one of Betty's killer goats gobbled up a passer-by and the washing got splashed with claret in the ensuing frenzy. Only joking.) Still, I think I might tell Mrs H. not to wash next Good Friday. Best not take chances, I always say.

Until recently I had neither seen nor heard anything which changed my mind about my 'bird fight' theory, but then I stumbled across something which made me wonder if there was more to this story than meets the eye. The north of England has, in my humble opinion, a rich mine of folklore the equal of any other in the world. Should you wish to explore it, you could do worse than to consult two classic works on the subject, namely, *Legends and Superstitions of Durham,* by William Brockie[1] and *Folk Lore of the Northern Counties of England and the Borders,* by William Henderson[2].

To my amazement, Henderson – whose book was first published in 1866 – records an old legend from Cleveland which states that anyone who washes clothes on a Good Friday will find them spotted with blood. Insofar as the Betty Heron story is concerned, this means that the mystery only deepens. Did some locals, aware of the superstition, deliberately splash the washing with blood to make Betty think she'd angered the almighty? Or was the blood that of a bird after all and the fact that it landed on the washing on a Good Friday merely a coincidence? An altogether stranger possibility is that the superstition is true, but I suspect that even seasoned paranormalists will find that hard to swallow!

Perhaps the cause of Betty Heron's bloodied washing will remain a mystery forever.

JACK THE RIPPER AND THE SOUTH SHIELDS CONNECTION

Ever since Stephen Knight wrote his controversial book, *Jack The Ripper: The Final Solution*[3], in which he suggested that a member of the Royal Family was implicated in the murder of several Victorian prostitutes, speculation on just who the Ripper was has intensified. What readers may not know is that the finger of accusation was once pointed towards a resident of South Shields, and to this day suspicion lingers as to whether he was in fact guilty of Britain's most notorious serial murders.

The Pall Mall Gazette, in December 1888, said that, 'In endeavouring to sift a mystery like this, one cannot afford to throw aside any theory, however extravagant, without careful examination, because the truth might, after all, lie in the most unlikely one'. That the police had already reached this conclusion was demonstrated by the fact that they actually paid a visit to South Shields, of all places, to investigate yet another potential suspect.

The Ripper murders took place between 7 August and 9 November 1888. Investigators were puzzled at the killer's apparent ability to just 'disappear', fuelling

1 Brockie, William, *Legends and Superstitions of Durham* (EP Publishing, 1974).
2 Henderson, William, *Folk Lore of the Northern Counties of England and the Borders* (EP Publishing, 1973).
3 Knight, Stephen, *Jack The Ripper: The Final Solution* (Granada, 1977).

suspicion in the minds of some that he may not have been a resident of London, and that he fled the capital immediately after each homicide. But if this is true, then where did he go? A widely held theory at the time was that he was a sailor who, after each slaying, laid low on his ship till it left port.

Between the first and second killings there was a gap of twenty-three days. Between the second and third killings there was an interval of seven days. The Ripper then became inactive for twenty-one days, eventually breaking this lull in activity with the slaying of Lizzie Stride and Catherine Eddowes on the same day. A further thirty-nine days elapsed before the murder of Jack's final victim, Mary Jane Kelly.

If Jack the Ripper was indeed a sailor, he certainly wasn't sailing around the world in between carrying out his attacks. He wouldn't have had the time. However, contemporary rumours that the killer's ship may have made regular trips between London and Bilbao on the Spanish Coast were not at all fanciful, as a quick jaunt south through the Atlantic into the Bay of Biscay did not take that long.

It was true that the interval in between the second and third killings was only seven days, but maybe Jack's ship didn't actually leave port during that week. Of course, all this depends on the assumption that Jack was a sailor being correct. But then something else happened which made the detectives hunting the Ripper wonder if Jack's seafaring destinations were simply other ports in the mainland UK.

During the first days of ripper hysteria, a young sailor had begun to frequent a number of bars and inns in South Shields. We do not know his name, which was withheld during the investigations, but several facts have come down to us through the passage of time.

- The man was a sailor who hailed from London.
- He came from a respectable family.
- He claimed to have been jilted and had a pathological hatred of women, particularly 'unfortunates', i.e. prostitutes.
- He showed signs of mental illness and was often seen talking to himself down by the docks.
- He would suddenly disappear for two weeks at a time and then re-appear again.
- He had an extremely melancholy nature and was continually sullen and moody. He was also rather unkempt and cared little for personal hygiene. Witnesses remember that he was particularly unhappy just after returning from his trips to London.

Despite his personality disorders and strange behaviour, the man was intelligent. He had taken to writing articles for a number of different newspapers and magazines, but the content of his submissions was strangely disturbing, so disturbing, in fact, that the editor of one journal decided, on a hunch, to compare his handwriting with that of Jack the Ripper.

Copies of the Ripper's letters to the police – taunting, 'come and get me' missives that infuriated the detectives working on the case – had been widely circulated. On comparing the handwriting on one of these copies with that on one of the manuscripts, the editor could not help but be startled by their uncanny similarity. He immediately contacted the police.

A senior detective and a surgeon, both working on the case, travelled to South Shields and talked to witnesses, including former drinking partners in various public houses. The more they talked, the more they began to wonder if the Ripper really had been

Did Jack the Ripper hail from South Shields? (Artistic representation)

in their midst. Had the officers been able to interview the man himself, I believe it is likely that he may indeed have been able to shed some light on the Ripper murders. Unfortunately they were denied that opportunity, for the man had died in rather bizarre circumstances some time previously.

After one of his trips to London, the sailor returned to the North. By this time his mental state had deteriorated to such an extent that he could barely string a sentence together. He was eventually found wandering the streets and hospitalised. Within a short while he had died, whilst in 'a state of great delirium'.

Curiously, the Ripper murders ceased at the same time that this strange, melancholy character died. So many unanswered questions remain about both his identity and the way he lived his life. If he was innocent, how was it that his handwriting was so similar to the Ripper's?

But if he was the killer of those Victorian 'unfortunates', all of whom died horribly at the hands of a maniac, then he took his secret with him to the grave. The notion that Jack the Ripper may have been connected with the North East was once explored on a TV documentary, and it was even suggested that he might have been responsible for a murder in nearby Birtley.

Rummaging through my files I retrieved a copy of *The Shields Gazette* from 14 September 1988, in which Janis Blower had discussed the very same theory in her 'Cookson Country' column. Ironically, Janis's article was published on the 100th anniversary of the ripper murders.

We may never be able to determine whether the Ripper truly did have a connection with South Shields, but the thought is certainly a chilling one.

CHAPTER 11

JINXES AND CURSES

The belief that people can be cursed – or conversely, curse others – is as old as the proverbial hills. Sometimes, though, it's not people that seem to issue curses but merely circumstances. Some would argue that a lack of self-confidence effectively means that we curse ourselves. Sometimes people who fail in life will claim that they are 'jinxed' as a way of deflecting attention from their own responsibilities and inadequacies.

Do curses and jinxes work? Sometimes they do, I believe, but working out the difference between someone who has been cursed by means of an arcane ritual and someone who is jinxed because they have come to believe so completely in their own destiny to fail is not easy.

NEWCASTLE UNITED AND THE 'LONDON JINX'

One Friday, my good friend and colleague Anna Kaye and I subjected ourselves to the ultimate rite of passage: an appearance on Goffy's early morning show on Century Radio. Survival would enhance our street credibility, but we ran the risk of being sunk without trace by one of the world's funniest but most acerbic presenters. Goffy, God bless him, has been known to fell oak trees with one lash of his Hartlepudlian tongue.

I uttered a prayer that the Great Editor in the Sky would make Goffy go easy on us, and that our kinship as fellow newspaper columnists would save my bacon. Well, the show went well, and during it Goffy treated us like royalty. 'What,' Goffy wanted to know, 'would the result be of the Fulham-Newcastle match the following day?'

It may seem strange that a radio presenter would ask two paranormalists to predict the outcome of a football match, so a word of explanation would be appropriate at this juncture. I've always been a fanatical supporter of Newcastle United or 'the Toon Army' as we Geordies call the team locally. However, several years ago Newcastle entered a disturbing period during which they just couldn't seem to win matches when they played in London. Eventually, this string of losses in the capital got so bad that rumours started to spread that there was a 'London jinx' or 'London curse' on the club.

Was there really a 'London jinx' on the Magpies, and if so could it be broken? Anna and I did our stuff. In a number of media interviews we described various psychic visualisation techniques which both players and supporters alike could use to urge the Toon on to victory. We both predicted – tentatively, I hasten to add – either a score draw or a surprise win for the Toon in the region of 2-1. We qualified our statement by saying it would be a closely contested match and that our intervention had, after all, been at very short notice.

Anna and I also predicted how certain players would perform on the day, and which Fulham players were likely to cause problems for Robbo's Army. Robbo, for the uninitiated, was the legendary Bobby Robson who was managing the club at the time. We emphasised that as we hadn't been able to talk to the Newcastle players individually before the match we couldn't be certain about the result, but that we were reasonably optimistic.

All of this should have been music to the ears of Toon Army supporters everywhere. Later in the day, however, we were told that a certain gentleman of Geordie extraction – and 'twas not young Master Alan Shearer, I may add – had announced on Sky TV that he was not exactly the world's greatest believer in the paranormal, or words to that effect.

So why were Newcastle apparently 'jinxed' when it came to London games? Alas, I suspect that some players may actually have begun to believe in the supposed curse, thus making it something of a self-fulfilling prophecy. Nothing makes a thing happen more quickly and effectively than the thought that it's inevitable. Believe you can't win a soccer match in London and you probably won't.

There was no psychic curse upon Newcastle United – just a lack of confidence amongst the players, I suspect. In time that confidence was restored and the 'curse' was broken. The team returned to winning ways in the capital – well, some of the time – and the only curse that now affects the club is when good money is spent on mediocre players.

THE CURSE OF THE CRYING BOY

There can be very few people who haven't seen the work of a mysterious Spanish artist who usually signs his pictures with the pseudonym G. Bragolin. Take a trip to your local flea market and I'd be surprised if there wasn't at least one Bragolin print to be found – normally in a gaudy plastic frame – sandwiched in between the second-hand Clint Eastwood videos and that awful hand-knitted pullover that some doting mum inflicted on her offspring last Christmas.

You must have seen them: the hauntingly beautiful oil paintings of crying boys – chubby-cheeked ragamuffins with pleading, tear-filled eyes. Even though the subject matter is depressing, prints of Bragolin's pictures have sold in the millions.

Intriguingly, Bragolin's series of crying boy pictures are said to be haunted. One story goes that the boys in the picture were orphans whom the artist befriended. After completing the series of portraits, it's said that the painter's studio burnt to the ground in a mysterious fire. Worse, one of the young boys who found fame through Bragolin's artistic talent was apparently burned to death in a car crash later. Whether any of this is true or not I haven't a clue, but what is true is that the paintings – both originals and prints – developed a hideous reputation for being cursed.

From around 1985 onwards, a series of mysterious house fires occurred throughout Spain and Italy. Investigators eventually noted that in each case a 'crying boy' picture, signed by Bragolin, was hanging in the premises. What seemingly drew the attention of the researchers was that the paintings were mysteriously left untouched even though everything around them would be burned to a crisp. One researcher told me that over seventy fires of unknown origin were recorded in which everything had been incinerated except the crying boy picture.

Disturbingly, what became known as the Curse of the Crying Boy eventually spread to the UK, although the number of fires in which a Bragolin painting was implicated never reached anything like that in mainland Europe.

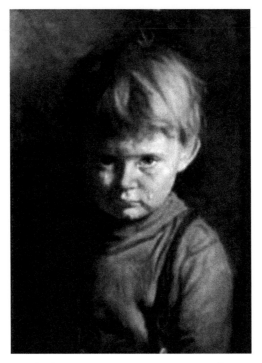

Are the famous 'Crying Boy' pictures cursed?

A group of devil-may-care firefighters, so it is said, actually hung a Bragolin in the canteen of their station, apparently in an effort to prove that the curse was nonsense. The next day a fire broke out in the same room. After it was extinguished the painting was hurriedly removed.

One newspaper even set up a service for worried readers, offering to dispose of any Bragolins sent in to them free of charge. Meanwhile, the curse spread to other countries, including the Netherlands. Holland even has a Crying Boy Fan Club dedicated to the pictures and the sinister influence they seem to exert.

Some clairvoyants claim that the paintings are haunted or possessed by the spirit of the boy whose face they capture. This is probably just fanciful embroidery to make a strange tale even stranger, but I have personally spoken to people who claim that hanging a Bragolin in their home precipitated disturbing paranormal phenomena. One man from Brockley Whinns told me that, after hanging the picture in his lounge during the 1980s, both he and his wife repeatedly saw a dark, shadowy entity walking around their home. They always knew when they would see something, because the picture would either fall off the wall or mysteriously turn around so that it was facing the wall.

It is said that the Curse of the Crying Boy is only activated when the owner of the print becomes aware that the curse exists. I'm glad then that the two Bragolins that my wife and I had hanging up in our hallway in the late 1970s have disappeared. I suspect we threw them out during a spring clean, although now I wish we hadn't.

CHAPTER 12

MEDICAL MYSTERIES

No one fully understands the intricate workings of the human body, although our current level of knowledge is far greater than in times past. There are, on the scientific horizon, several real possibilities that a number of deadly diseases, including some forms of cancer, may at last be conquered. Although the diagnosis of illness and disease has reached a very sophisticated level, every now and then something happens to skew the pot. Medical mysteries are still with us, and although some may ultimately be explainable they can often present themselves in such bizarre circumstances that they still enthral us. Here are some of them...

DEAD AND BURIED?

There are a number of urban myths in circulation at present, some of which are generally accepted as true by the general public. You may have heard some of them: the maniac who places HIV-infected needles on cinema seats, the 'terrorist' who has placed a bomb in a shopping centre to be detonated at a particular time, and so on. I have dealt with a number of these tales in my 'WraithScape' column. Fortunately the majority are nothing more than fiction, but a number actually have some basis in truth.

One of the most common stories of this ilk concerns the burial of people who are supposedly dead, only for it to be discovered later that they were merely unconscious. In most versions of the tale, the coffin would be opened later and scratch-marks would be discovered on the inside of the lid, indicating that the person inside had regained consciousness and made a desperate bid to free themselves.

In Victorian times a number of devices were available to circumvent such tragedies. One involved the use of a cord which went from the inside of the coffin to the surface where it was attached to a bell on a stand. If a supposedly dead person 'came back to life' so to speak, they could pull on the cord, thereby ringing the bell and alerting passers-by to their plight.

Of course, the obvious question has to be whether people have been buried alive at all, or whether such tales are purely fictitious. Sadly, it seems that on a number of occasions supposedly deceased people have been interred when in actual fact they were very much alive.

In 1894, for instance, *The Cork Herald* reported that a labourer was buried in Douglas, County Cork, Eire. On Thursday, 17 May, the coffin was lowered into the grave when, after the first few shovels of earth had been cast, a noise was heard coming from within the casket. The coffin was immediately removed and opened and, to the

Over the years a number of people have been buried alive,
prompting nineteenth-century families to attach a bell to a rope
which led into the coffin so that 'living' corpses could ring it if
they regained consciousness in the grave. (Artistic representation)

dismay of those gathered, the 'corpse' was found to be lying face-downwards. *The Cork Herald* reported that, 'his features were contorted and almost black, with every sign of a desperate struggle in the endeavour to open the coffin'. Suddenly the poor man 'throbbed convulsively' and then passed away. His rescue had come too late. An inquest was organised and one suggestion was that the labourer had been in a trance of some kind. Not all urban legends are untrue, it seems.

Of course, advances in medical science mean that the likelihood of such a thing occurring in our present day is unlikely in the extreme. However, it is not impossible. In the USA there have been reports of a number of 'corpses' bleeding profusely when the pathologist first attempted to cut open the body. Of course, if the heart isn't beating then this shouldn't happen, and if the tales are true then a number of lives may have been saved in the nick of time. Gruesome, but better than being buried alive, I suppose.

Still, the legend continues. In 1990 a horror film called *Buried Alive!* was released, fuelling even more speculation that those who are buried may not necessarily be deceased. Newspapers recently reported the emergence of a new 'sport' of being buried alive for a fixed period of time. There is a clothing company called *Buried Alive* and, would you believe, a board game of the same name too. Maybe the Victorian bell-pull idea wasn't so daft after all.

South Shields has, as you may imagine, a number of such tales in its folk history. The graveyard next to St Hilda's church in South Shields plays host to a number of very old graves and their occupants. There was a time when the families of deceased people would pay watchers to sit over the burial plots of the deceased for twelve days, or until the soil had 'fully settled'. This made it far more difficult for grave robbers to carry out their nefarious business.

THE DRUNKEN GHOST

There is an old story, of uncertain provenance, about an elderly chap who succumbed to a surfeit of ale in one of the drinking dens at Comical Corner during the mid-nineteenth century. The chap apparently had lodgings near Claypath Lane and his walk home – albeit with an unsteady gate – took him past the aforementioned graveyard at St Hilda's. As he picked his way through the tombstones, he accidentally stumbled into an empty hole that was due to receive a coffin the following morning.

Cursing his own stupidity, the reveller picked himself up and tried to extricate himself from his predicament, but could not as the sides of the hole were too steep. Every now and then he would hear footsteps passing nearby, and would shout, 'Help! Is there anybody there? Help!'

After several attempts, but with no success, he was about to give up but decided to have one last go at attracting attention. 'Is there anybody there?' he bellowed as loudly as he could. 'Aye, I'm here, matey!' whispered a voice just behind him. The man, horrified, threw himself upwards with all of his might and managed to clamber out of the hole in a state of sheer terror. He looked around, and immediately saw the origin of the eerie voice. A fellow drunkard had fallen into the hole sometime before him, and had been lying in the corner all the time!

Another tale concerns Westoe Cemetery in South Shields, when two women claimed to have seen a glowing figure climb out of a grave one winter's evening. It's certainly true that Westoe Cemetery is haunted, and I had a peculiar experience myself there several years ago.

In 2002, in response to a number of sightings of spectral figures at that location, I went to Westoe Cemetery with some colleagues from a local paranormal research society. We walked around the graves that Sunday afternoon, looking for anything out of the ordinary, but could see nothing out of place. After forty-five minutes or so we decided to give up our search and made our way towards the exit. It was at this juncture that a number of strange things happened.

First, a colleague spotted a strange simulacrum upon a tombstone. A simulacrum is, for those who don't know, a naturally formed image or shape that looks eerily like something else. When you see faces in the clouds, or dancing elephants in the flames of a fire, you are looking at simulacra. The tomb in question was made of sandstone, and was starting to 'flake' due to decades of exposure to the elements. This process of delamination had created a shape on the marker very similar to a human face, so similar that I was intrigued enough to photograph it.

As we walked towards the main road I then had the feeling that we were being followed. On several occasions I turned and could see nothing, but on the final occasion I was startled to see a large German Shepherd behind me. It simply stood there, staring, and I must confess that the hairs on the back of my neck stood on end. One of our group had his own German Shepherd with him, which he'd brought along for the walk, but it seemed blissfully unaware of the presence of the other dog. I took a photograph. We continued to walk on, and the next time I turned my head the other dog had disappeared. To this day I'm convinced that there was something spectral about that canine interloper.

Just before we left the cemetery, I was suddenly hit on the head by what felt like a small pebble. This was rapidly followed by two others. I turned, but there was no one there. 'Did you feel that?' said a colleague standing next to me. He'd been hit on the

back of the head too. I can testify that there was absolutely no one around who could have thrown those stones – at least, no one we could see. Later, I heard of others who had endured exactly the same experience in the same place.

PHANTOM LIMB SYNDROME

Speak to anyone who has ever had a limb amputated and they will tell you that it is one of the most traumatic experiences that you can go through. Losing a part of your body that you have had almost since conception can be very hard to deal with. However, strange though it may be to find yourself without a limb, even stranger is the sensation that you've got it back again.

The condition is known as Phantom Limb Syndrome, the strange feeling that a limb that has been amputated, or lost in an accident, is still there. Explanations for the phenomenon abound, but no one really knows the cause. What we do know is that it can produce the most baffling sensations which, in some respects, defy the normal paradigms of science.

Frank (not his real name) is a friend of mine who some years ago had part of his foot amputated. I asked him if he ever felt that the part of his foot that was taken off was still there, and he was in no doubt whatsoever. 'Yes, I can still feel it,' he said, 'sometimes it gets itchy, sometimes I even feel pain. It's strange.'

Phantom Limb Syndrome is also common amongst those injured in battle. So, what could be the cause? One theory is that when a soldier is aware that they have lost a limb, the mind still cannot fully accept that the limb has gone and therefore sends 'fake' nerve stimuli to the brain in an effort to maintain a sense of normality. During the First World War, however, medics often spoke of injured soldiers screaming in agony about the pains in their legs or arms, not realising that the limbs in question had actually been blown completely off. So, attractive though it is, this theory is unlikely to be true.

Another theory – and a far more controversial one – is based on discoveries made by a Russian engineer called Semyon Kirlian. One day in 1939, Kirlian was working in his laboratory when he accidentally moved his hand too close to a live electrode. Shocked but unhurt, the researcher wondered what had caused the brilliant flash of light which accompanied the sudden discharge of electricity. His curiosity heightened, the engineer decided to experiment. He placed a sheet of thin, light-sensitive card in front of his hand, and then placed the card in the path of the spark given off by the electrode. On developing the picture Kirlian was amazed to see the image of his hand surrounded by a strange glow. Peculiar streamers of light were also emanating from the fingertips.

Kirlian began to carry out further research in earnest, and speculation grew that what he had captured on film was the 'aura' which psychics have for centuries claimed to see around the bodies of those they talk to. This theory was bolstered when Kirlian and other researchers found that the aura given off by a diseased person or plant was markedly different from that of a healthy person or specimen. This also supported the claims of psychics that they could tell by studying a person's aura whether they were ill, healthy, happy, distressed etc.

Eventually Kirlian made what was his most surprising and perhaps most controversial discovery. Accompanied by his wife, he photographed a leaf using his now established technique. He then photographed the same leaf after tearing off a large section of it. To his amazement, when he photographed the damaged leaf an aura of the complete leaf

Kirlian photography can detect strange discharges from living things. Some believe they may be 'photographs of the soul'. (Artistic representation)

appeared! It was as if the detached part of the leaf was still there in some way. Now, some researchers are suggesting that Kirlian may have stumbled upon the cause of Phantom Limb Syndrome.

Could it be that, when a limb is amputated, the aura that surrounded it is still there, generating phantom or psychic sensations which feel like the real thing? Further experiments are apparently being carried out in the Ukraine to see if blindfolded amputees can 'feel' their phantom limbs when they are stimulated by heat, cold, pinpricks etc. Even more bizarrely, experiments are being designed to see if amputees can be trained to actually move physical objects with their phantom limbs. If this were possible, it would rewrite just about every scientific textbook that has ever found its way into print.

One thing that both Kirlian's supporters and detractors seem to agree on is that the human body is far more complex and mysterious than we will ever know. Perhaps, one day, the mysterious phenomenon of Phantom Limb Syndrome will be explained. For now we can only guess.

DISEMBODIED VOICES

I often receive correspondence from people who are genuinely convinced that their homes are haunted. It's not possible to answer all such queries personally, but whenever possible I'll take the opportunity to give some practical advice to readers who may be really frightened by one strange phenomenon in particular occurring around them, and they just don't know where to turn. One of the most common queries I receive concerns

disembodied voices. Hearing voices when no one is around is far more common than you might think, and the truth is that there are far more likely explanations than hauntings.

There are a number of illnesses that can cause this symptom – some psychological, some physical – and in most cases they can be treated successfully. People who've read my column over the years know well that I don't rule out a paranormal cause for disembodied voices, but the first thing to do is pay a visit to your GP who can assess whether you need some medical assistance. There should be no stigma attached to this. You'd be amazed at the number of famous actors, writers and politicians who've endured the same, troubling symptom. It can be extremely difficult for victims of such phenomena, and their partners, to come to terms with the fact that a medical condition really is the most likely cause.

Often, those who hear disembodied voices will report other strange phenomena occurring around them, such as seeing apparitions of people or objects in their home. Others report a constant feeling that 'something is going to happen' although they can't say exactly what.

I once spoke to a famous footballer from abroad who had a highly successful career and was capped many times for his country. He was desperate for help because he kept hearing voices in his head that were giving him 'messages'. I urged him to seek medical help. Doctors discovered a previously undiagnosed condition that was causing the problem. It was treated successfully and he is still enjoying a successful footballing career, now as a manager.

If someone close to you says they are hearing voices in their head do not scold or belittle them. They are not 'imagining' things. The voices are very real to them. What they need is love, encouragement and support to get them through the problem whilst they are seeking medical assistance. The good news is that there are now treatments available that can often make these frightening symptoms disappear very quickly, and there are other therapies that can, in the long term, prevent them from reoccurring. Believe it or not, a common cause of hearing disembodied voices is a lack of sleep. Some sufferers, terrified they are developing serious mental illness, feel a great sense of relief when told that the cause is so simple and can be successfully treated.

Some disembodied voices, however, are not caused by medical conditions. One case I dealt with concerned a woman who kept hearing the sound of a man's voice in her kitchen. Most times she couldn't make out what the voice was saying, as it just sounded like 'mumbling'. On other occasions, however, the words were clear. She once heard the voice say, 'I'm not going away. I'm staying right here!'

I did some background research and eventually managed to interview the previous tenant of the house. I asked him if he'd ever had any strange experiences in his former home and he quickly answered in the affirmative. 'Its funny you should ask that,' he said, 'sometimes I was convinced I could hear voices, you know... a man's voice. It would say, "I'm staying right here! I'm staying put!" I know this sounds strange, but I'm not bullshitting you – it was a real voice.'

I asked the man if there was any particular location in his old home where this would happen, and he told me that other than one or two occasions it had always happened in the kitchen. This left me in little doubt. It was the same voice, in the same place, saying the same things. There was no doubt in my mind that the cause of the voice in this instance was not an underlying medical condition but the presence of a disembodied spirit. In a case detailed earlier, a doctor was able to prove that the voices – also heard in the kitchen – had some form of objective reality.

Currently, those who hear disembodied voices – whatever their cause – will rarely go public and admit it as the fear of being ridiculed is too great. Hopefully, one day, that will change.

THE STRANGE TALE OF THE EGYPTIAN HEALER

A reader of my 'WraithScape' column, Charles Wilkinson, recently sent me a letter that contained a fascinating story told to him by his grandfather when he was a child.

Jim's grandfather, Matthew Brown, had a friend who ran a thriving import business just after the First World War. To the best of Jim's recollection, his grandfather's friend was called Henry and he lived somewhere in Central London. Other than these fragmentary snippets of information, Charles knows little about Henry, except that he travelled the world a lot. In 1919, Charles says, his grandfather's friend visited Egypt on business. He had ensconced himself in a luxurious Cairo hotel under an assumed foreign name, due to the fact that there was some unrest in the area, during which, apparently, several Englishmen had been attacked.

Two days into his visit, Henry fell sick. He began to sweat profusely, shake and then vomit. His temperature soared, and, whilst lying in his hotel room, he began to suffer hallucinations. His condition worsened as he drifted into a deep but fitful sleep. At some point during the night Henry awoke and had the strange feeling that someone was in the room with him. He could see the interior of the room clearly in the moonlight, and as he turned his head he was shocked to see an elderly man dressed in Egyptian garb standing by his bedside. Before Henry could speak the man placed a forefinger to his lips, as if to indicate that he should remain silent. Henry watched in amazement as the man leant forward and placed a small object on the bedclothes. He then touched Henry on the forehead with the index finger of his left hand, at which point Henry lapsed into unconsciousness.

The following morning Henry woke, but felt no better. He remembered the old man, but naturally assumed that his presence had simply been a hallucination precipitated by his high temperature. But then he noticed the small bottle lying on the bed. It was quite ornate, fashioned from green glass and sealed with a leather stopper. Henry knew it had not been there the night before. The only explanation Henry could arrive at was that the old man had not been a hallucination after all, and that the bottle was the object that he had seen him place upon the bed.

Henry picked up the bottle and examined it closely. A small piece of paper was gummed to one side with a hand-written message upon it that read 'MEDICINE FOR YOU TAKE NOW'. The first thought that crossed Henry's mind was that this was a trick of some kind. Maybe the liquid in the bottle was poisonous. But then again, if the old man had wanted him dead, he could simply have cut Henry's throat whilst he was sleeping. Throwing caution to the wind, Henry removed the stopper and poured the contents of the bottle down his throat. Within the hour he had made an astonishing recovery.

Henry never did find out who the old man was, or why he had gone to such extraordinary lengths to cure a complete stranger of his fever.

THE HORSLEY HILL HEALER

Some time ago I was made privy to a fascinating story which had its centre of gravity in the Horsley Hill area of South Shields. This is not the first time I've heard this tale, and I'm hoping that readers of this book may be able to fill in some gaps. First, though, we need to set the scene.

South Shields in the nineteenth century was not as you see it now. With the exception of the river front and several local pit sites, there was a far greater preponderance of rural

Mary the Horsley Hill healer, who treated locals with her homemade potions. (Artistic representation)

territory than there is now. Communities were much more closely knit, and what we now know as 'the statutory services' were far less visible and certainly not as accessible. The rule of 'survival of the fittest' still had a great influence, socially speaking.

Medical treatment was very different: crude, not always efficacious and rarely available freely. This circumstance paved the way for a large number of unregistered healers to offer alternative treatments at a reduced price, or even free of charge. Hardly a street was free of at least one herbalist or healer who could be consulted about all manner of ailments. One of these unorthodox street physicians allegedly lived at Horsley Hill, and was well respected for her abilities. Her name, I have been told, was Mary.

Mary apparently lived in a cottage that stood on, or near, the site of the present Horsley Hill Square. Mary's expertise lay in the preparation of salves, now generally called ointments, which were used to treat a variety of conditions. According to tradition, Mary would mix a number of different herbs, spices and fats to make up her treatments. These would then be dispensed on mussel shells gleaned from the beach, which made handy little containers. Mary had salves for skin rashes, salves for eye infections and salves for rheumatism. Toothache? Scrofula? A touch of the humours? Mary would sort you out, no worries. What she charged was only what you could afford.

Healers like Mary were well respected, but not everyone enjoyed their presence. Some critics – doctors of medicine, usually – were quick to condemn their unregistered counterparts as at best incompetent and at worst evil sorcerers in league with Beelzebub himself. These negative criticisms were usually ill-founded as many folk remedies were tried and tested cures which had been passed down from generation to generation. Ironically, modern science has validated many of them.

Back to Mary at Horsley Hill. Apparently she had a two-part stable-type door leading into her scullery (now there's an old-fashioned word). Every morning she would open the top half and dispense her salve-filled mussel shells to all who needed their mysterious and efficacious contents. When Mary died, the secret of her folk medicines died with her, and the good folk of Horsley Hill were the poorer for it. She may have been viewed with suspicion by the great and the good, but Mary and those like her were true public servants.

CHAPTER 13

MYSTERY CREATURES FROM BEYOND

The world we inhabit is a strange place indeed, although many people prefer to live in ignorance and close their eyes to the fact. 'What we don't know won't hurt us,' we are told, which has to be one of the worst pieces of advice ever given. Trust me, there are bizarre animals roaming this planet – as yet unclassified by science – that you wouldn't want to get too close too. It's easy to pour scorn on those who report seeing brutish creatures like Bigfoot, the Loch Ness Monster or the Yeti, but there are simply too many credible eyewitnesses to their existence to dismiss them lightly. If you go down to the woods today, you really MIGHT be in for a big surprise.

Thousands of years ago, South Tyneside was a radically different place, as you may well imagine. Stand at the junction of King Street and Ocean Road – gazing towards the coast – and you'll see a profusion of exotic Asian restaurants, wine bars and fast food takeaways. Look to the left and you'll see ASDA. Pan to the right and your eyes will come to rest upon the stately South Tyneside Museum.

If, however, you were to travel back in time to the era of the Roman occupation, you would find yourself floating – or, if you're a non-swimmer, sinking – in the middle of a meandering river. Where petrol-driven vehicles now roam, boats once sailed. Verdant forest and rich woodland was the norm, and no one was ever more than a stone's throw away from nature. Like I said, it was a different place.

Over the centuries, the relentless march of urban 'civilisation' – and I use the term loosely – has all but destroyed what was once an extremely green and pleasant land. We now live in a concrete jungle, and our wildlife is having to pay the metaphorical mortgage. Literally hundreds of varieties of flora and fauna have disappeared. Brown bears no longer roam freely. Wolves cannot be seen padding through dense foliage, and past is the time when wild boar could frighten the life out of the unwary traveller. Sadly, they are all gone. Or are they?

Believe it or not, there are many new species of animal on this planet which have yet to be discovered. Some will inhabit the distant reaches of the Amazonian rain forests. Others may be found in remote areas of the Tazmanian bush. And some, without doubt, will be living right here in South Tyneside.

If the idea that our small borough could be playing host to strange, unknown creatures sounds like the ramblings of a demented madman, then you may be in for quite a shock. To prove that we may indeed have animals as yet unknown to science living virtually on our doorstep, we must first visit that mysterious Oriental isle, Hong Kong.

Hong Kong has a mere 382 miles land surface. It is less than half the size of Luxembourg – which is tiny in itself – and has a population of 6 million. Its population

density is a staggering 15,000 people per square mile. Bearing these facts in mind, one could be forgiven for assuming that there would be little or no room left for unknown animals to wander around, for even the island's rural areas have been well studied and investigated by naturalists for centuries. But you'd be wrong.

In the last decade alone, three new types of rodent, a new kind of mongoose and a never-seen-before large salamander have all made their entrance onto the zoological stage. One naturalist recently commented that the list of reptiles and amphibians that have been recorded from the territory is growing almost daily.

Jumping across to Australia, we find several new species of lizard making their first public appearance too. Where were these found? Out in the barren wastelands of the Gibson Desert? Not a bit of it. They actually turned up slap bang in the middle of Sydney! Meanwhile, not that many miles away, a new species of fresh-water fish was found swimming around in a large rain puddle. Scientists haven't the foggiest how it got there.

Moving closer to home, my archives contain a newspaper clipping from the *Daily Mail* of 10 October 1988. The article concerned a mysterious beast, responsible for the slaughter of literally dozens of sheep in the Welsh hills over a period of several weeks. The beast – dubbed the Welsh Waterwolf, because hunting dogs always followed its scent back to local rivers – would leave a small puncture wound on the breastbone of each victim.

So what was it? Scientists from a local university ruled out all known predators, including foxes, dogs and even escaped wildcats. The hot money was wagered on the creature being a hitherto unknown type of giant otter, or perhaps an undiscovered kind of mink. And before you laugh at the idea of giant otters rambling around the Welsh hills without being noticed, remember Hong Kong and Sydney! But what about South Tyneside? Could we really be sharing our little bit of England with some bizarre creatures and not even realise they are there? The blunt answer is, absolutely.

Bernard Heuvelmans was probably the world's foremost cryptozoologist – that is, someone who specialises in tracking down previously unknown species and proving their existence. Heuvelmans was the first to admit that new species can turn up anywhere. He actually discovered an unknown member of the cat family, not in the wilds of Papua New Guinea, but in France!

Hard to believe maybe, but the likelihood is that there could be dozens of new creatures, unknown to science, living right under our noses. True, most would likely be small and insectivorous, but we cannot rule out the possibility that larger species may be there too. Recently, a giant peccary was found in Paraguay, a colossal gecko in New Zealand and a huge parrot in the Philippines. All these animals were hitherto unknown to the experts. I have recently received reports that the moa bird, thought to have become extinct in the nineteenth century, has also recently been spotted in remote areas of New Zealand.

But there is yet another way in which unknown animals can exist in close proximity to humans without being recognised for what they are. Sometimes, two entirely different animals may look almost identical in appearance, whilst taxonomically they have nothing in common. It's only when an expert examines the beast close up that we realise that there's a 'new kid on the block', so to speak.

Whilst its unlikely that we'll ever see anything like Bigfoot or Yeti suddenly putting in an appearance in the Marine Park, we cannot dismiss the possibility that there may yet be unknown and even strange animals hiding in the quieter recesses of South Tyneside. Remember that the next time you hear scratching noises in the loft...

The Shony, South Tyneside's very own sea monster, has been spotted numerous times over the last century. (Artistic representation)

THE SHONY

Sea monsters are the stuff of legends. For thousands of years, intrepid mariners have spoken of encounters with strange and terrifying creatures from the deep. Of course, such frightening beasties would never be found frolicking in somewhere as mundane as the North Sea – would they? Actually, the north-east coastline has played host to quite a few sea monsters over the years, and at this juncture I should warn the faint-hearted that they are most definitely *not* the sort of creatures you'd like to bump into if you're looking for crabs down near the groyne or winkling beside the pier.

Back in the eleventh century, corpses were washed up on the shore with disturbing regularity. These bodies were badly mutilated, and normally had their eyes missing. At first the locals were puzzled, and then reports were made of a huge, nut-brown coloured monster seen swimming nearby. The monster was very quickly made the culprit, of course, but by the early part of the fourteenth century the number of bodies being found diminished. Slowly the local populace began to think that maybe there was no monster after all. Perhaps the mutilations had been caused by the corpses being dashed against the rocks, and the missing eyes could be put down to natural scavengers such as eels and crabs.

But why did the mutilated bodies suddenly begin to turn up? And why did they just as suddenly stop? Surely, if there was a more rational explanation, or some sort of natural process involved, we should still be getting mutilated corpses washed up on our beaches today. Actually, the idea that there really was a monster lodging in the North Sea is supported by the consistency of the eye-witness testimony.

THE BERTIE

One day during 1881, a Scottish fishing vessel called *The Bertie* was out in the North Sea during fairly calm conditions. In the afternoon, whilst the crew were busying themselves, the

The crew of *The Bertie* had a terrifying encounter with a sea monster during the nineteenth century. (Artistic representation)

peace was disturbed by a huge marine animal with a large hump on its back, which not only reared out of the water but – to the horror of all on board – proceeded to attack the ship. As the massive animal careered against *The Bertie* time after time, the captain feared that the vessel would capsize. In desperation he ordered a crewman to fire a rifle at the creature. This stopped the attack for a short while, but then it resumed with even greater ferocity.

For several terrifying hours, the crew of *The Bertie* played cat-and-mouse with the monster. By dusk the captain was convinced that it was only a matter of time before the ship sunk beneath the waves. However, just as suddenly as it had appeared it returned to the deep, leaving the thankful crew behind to sail home with their story.

The reason I'm so convinced there really just might be a huge aquatic creature in the North Sea is that I might well have had an encounter with it myself. On 11 August 1998, my wife and I were travelling towards Whitburn along the coast road, near Marsden Rock at South Shields, when I happened to gaze down at the sea. About 30yds from the shore was a huge, brown hump just breaking the surface of the water. Although only a small area was above water level, I could clearly see a much larger area just under the surface. For a second I thought my eyes were playing tricks, and then I shouted, 'Can you see that? What on earth is it?' Fortunately, my wife saw it too, although she hadn't the faintest idea what it was. We parked at the next head of cliff and looked down again. It was still there, but now submerged entirely. Through the waves we could still see its brown colour, although the shape was indistinct. After a minute or so it disappeared.

When we arrived home, our copy of that evening's newspaper was waiting for us. There, on the front page was what seemed to be the answer to the mystery: a photograph of a bottle-nose dolphin which had been swimming near the coast and attracting considerable attention. So that was that, then.

Or, perhaps not. The thing my wife and I saw looked far too big to be a dolphin, and the colour wasn't right for a bottle-nose anyway. Still, we convinced ourselves that it must have been the dolphin we'd seen, and that we'd simply got carried away with excitement and imagined that it was larger than it really was. And then, just when we thought it was safe to go back in the water, as they say, I got a 'phone call.

The crew of the *Black Eagle* salvage ship had an encounter with the Shony off the coast of South Shields in 1946. (Artistic representation)

One of our local councillors (who doesn't wish to be named in case his colleagues start to think that he isn't exactly 'knitting with both needles', to quote his own words) telephoned me an hour after I'd arrived home about a business matter. I happened to mention Daphne the Dolphin, as locals had named her, and how I thought I'd seen her, despite her apparently colossal size. 'Funny you should mention that', said Councillor X. 'I was buying some fish and chips in Ocean Road when I overheard two men in the queue talking about the dolphin. I definitely heard one of them say, "No way was that a dolphin. What I saw could have swallowed a dolphin in one gulp".'

I happened to mention the incident to a good friend of mine, Malcolm Urquhart, who told me that around 1969-70 a local newspaper reported that a sea monster had been seen off nearby Frenchman's Bay. He thought he had the cutting but, alas, it proved to be as elusive as the monster itself. However, another friend, Ivor Muncey, informed me that the monster had also been seen near Marsden Rock in 1945. That sighting had also made the pages of the local paper, apparently.

So then, did South Tyneside have its very own sea monster, a rival to the legendary Cornish sea monster Morgawr? Was it possible that a real, live plesiosaur was living near our scenic coastline? If so, could Plessie be a rival to Nessie?

I appealed in my 'WraithScape' column for any other sightings that might have been made over the years, and subsequent investigations revealed that my wife and I had actually joined an elite group of South Tynesiders who believed they had witnessed the borough's very own sea monster. In the article I also asked readers to help me track down press cuttings of this mysterious creature, and I was not to be disappointed.

On Thursday 9 November 1986, a newspaper columnist recalled a bizarre encounter from forty years previously when a strange, Nessie-type creature was spotted off the coast near Trow Rocks. During 1946, salvage work was taking place on the wreck of a ship called the Eugenia Chandris. Heavily involved with the operation was a steamer called the *Black Eagle*, which at the time of the incident was apparently standing off the wreck of the Chandris. It seems that, at some point, some of the crew of the *Black Eagle* spotted a huge 'head and neck' rise out of the water to the height of 6ft, a sight that

would undoubtedly have frightened the life out of most mortals. The crew of the *Black Eagle* was made of sterner stuff, however, and they decided to give chase. Standing by was a motorboat belonging to the steamer, and it was this small vessel which took off in hot pursuit of Plessie. For ten minutes the motor boat chased the monster back and forth along the coastline, but the creature managed to keep just ahead of them.

There is a curious feature about this report from 1946 that caught my eye. Apparently, the crew of the motor boat was desperate to pull alongside the monster so that they could – and I quote – 'get a sideways view to see if it had the same distinctive profile as "Nessie".'

Now it is true that photographs of the Loch Ness Monster had been taken prior to 1946, but the only one to gain any real exposure in the media before then was the famous 'surgeon's photograph' taken by R.K. Wilson in 1934, apparently showing Nessie's head and neck sticking out of the water. Recently this photograph has been denounced as a fake, allegedly due to a confession made by one of the supposed pranksters who claimed that the monster was nothing more than a carefully-sculpted model made from modelling clay and a toy submarine. Further, we now know that Wilson was a well-known practical joker, and the case for the photo's authenticity is not helped by the fact that it was supposedly taken on 1 April! However, not everyone is convinced. It is also true to say that attempts to recreate the hoax have not been entirely successful.

The jury is still out on the 1934 photograph, but now let's return to the incident at Trow Rocks. Had some of the crew of the *Black Eagle* seen the controversial 'surgeon's photograph', and is that where they gained their impression of what Nessie should look like? Maybe, but I'm sceptical. Wilson's, picture, for all its notoriety, is neither clear nor distinct. Further, the neck of the animal in Wilson's picture does not entirely match the long, six-foot neck described by the crew of the *Black Eagle*. We also have to remember that newspapers and magazines were – apart from the Pathé news bulletins at the cinema - the only widely available visual news media at the time, and the scepticism of many editors prevented them from publishing Wilson's photograph. So, is it possible that some of the crew of the motorboat had actually seen Nessie themselves? Or were they relying on the second-hand tales of those who had fished at Loch Ness and spun vivid stories of what they had seen there? We may never know. Eventually Plessie sunk beneath the waves, leaving the crew of the motorboat and their shipmates on the *Black Eagle* to stare in wonderment at the sea near Trow Rocks.

Actually, reports of huge, serpentine sea creatures in the North Sea go back millennia. The Romans used to throw coins in the water as an offering to it, and the Vikings later named it the Shony after a sea-deity.

Whatever my wife and I saw that day, I don't think it was Daphne the Dolphin – but I'd dearly love to see it again.

THE CLEADON PANTHER

A reporter from our local newspaper had been doing his best to find the Cleadon Panther, and so had I. The questions which the good folk of Cleadon needed answering, back in 1999, were a) 'does it exist?', b) 'what is it?' and c) 'will it have me for breakfast?', although not necessarily in that order.

Firstly, I think we can safely say that something was out there roaming around the fields of Cleadon, and it wasn't Twinkles the cat. Four independent witnesses stated that it was – to quote one of them – bigger than a Great Dane. It was also jet black, had a large, straight tail and was unlikely to have its hunger sated by a can of Kittychunks. We were talking Big Cat here.

On Tuesday 12 January – the day after the local newspaper broke the story – I set out at the crack of dawn to find our feline interloper. It was snowing, and as I walked past the duck pond towards Cleadon Lane I was conscious that the landscape had a very Dickensian – and spooky – appearance. There is a common myth that wild cats roam around the countryside looking for humans to devour. This is rubbish. Unless a wild cat is threatened, demented or very, very hungry it will keep well away from humans. This is why, despite hundreds of sightings of mystery big cats over the years, only a handful of them have ever been caught.

There is a belief amongst some mystery big cat researchers that up to eight viable breeding populations of wild cats are now housed within mainland UK. One of those groups, it is rumoured, is situated in County Durham. Conventional wisdom has it that these breeding groups are made up of big cats that were released into the wild by their owners, after they were unable to comply with new government restrictions concerning the keeping of exotic pets. Rather than have them put down, they let them go. But there is another explanation for sightings of mystery big cats. There is a theory, which is increasingly gaining acceptance by researchers, that some of these animals are not 'real' animals in the accepted sense of the word. Rather, they are known as 'zooform' animals – that is, apparitions that look like real animals but are actually ghost-like entities. This theory would explain certain peculiar facets of many mystery big cat reports. For instance, some MBCs are reportedly seen without limbs. Commonly, witnesses will say that the lower parts of their legs were missing, giving the animal the appearance of floating above the ground. Mystery big cats are also reported to have bright, glowing eyes of a fiery red colour. Witnesses will often describe them as unnatural or frightening.

Personally, I believe that both explanations can be valid. There are definitely wild cats breeding in our countryside, and the Cleadon Panther may have journeyed down from Durham in search of pastures new. On the other hand, some MBCs definitely display bizarre characteristics which are not common to conventional animals. One witness from Cleadon told me that she saw the beast walk across Sunderland Road before suddenly disappearing. This is typical behaviour for a zooform creature.

Only time will tell which category the Cleadon Panther belonged to, but I will put my neck on the line now and make a prediction: whatever the creature was, even if it returns it won't be caught. Statistically, real, live mystery big cats are rarely captured. They are experts at avoiding humans and can survive for months – even in urban areas – without being seen. Further, if the creature was/is not a real cat but a zooform apparition, then it will likely follow a predictable pattern. The creature will probably appear here and there for several weeks. It may even leave tracks and droppings. (Although you would be forgiven for thinking that only real creatures leave such telltale signs, zooform animals can also leave droppings and paw prints too. How this happens is anybody's guess.) Appearances of the creature may be accompanied by flashing lights and strange, sulphur-like smells. Eventually the sightings will stop.

Whether these creatures are real or zooform apparitions they should not be approached. Real big cats may attack if they are approached, and zooform animals have been known to give off large amounts of electrical energy when touched. Sadly, there are several well-attested deaths and serious injuries which have resulted from witnesses attempting to pat, stroke or touch zooform animals.

One of the biggest problems in getting people to report sightings is the fear of ridicule. Reporting that you've seen a panther wandering around your neighbourhood is bad enough, but try telling the police that it had glowing red eyes and disappeared in a flash of light and those nearest and dearest to you may well begin to question your sanity. My advice is to report it anyway. When more people begin to admit publicly the reality of paranormal phenomena, the quicker the stigma will disappear.

And did I see anything in the fields at Cleadon? Yes, but I'm not sure what it was. As I walked up Cleadon Lane I looked across the field opposite the infants' school. Four ponies stood there. Three were in a group, one on its own. Suddenly, the lone pony whinnied and scampered over to where the others stood. All four looked nervous and unsettled. Beside the hedge I caught a fleeting glimpse of a dark shape, and then it was gone. Perhaps it was a large dog, perhaps not.

On 31 July, I told readers of my column that there was every likelihood strange creatures were living right under our noses in South Tyneside. Previously I recounted how witnesses had reported seeing peculiar lights and unmarked helicopters over Cleadon Hills. In the USA it is common knowledge amongst researchers that the appearance of zooform animals is often preceded by sightings of UFOs, strange lights and unmarked military helicopters.

What the Cleadon mystery big cat was we may never know, but I'll tell you one thing: if you've a passion for the paranormal, then South Tyneside's the place to be.

THE TERROR-PACTYLS

Some years ago, a reader of my 'WraithScape' column told me of an extremely strange experience. Andrea F. had been sitting in her living room looking out of the window when she suddenly noticed 'a large shadow' looming over the garden. Puzzled, she was just about to get up and take a closer look when, to her amazement, she saw a colossal creature dive down towards the lawn. 'I only saw it for a split second,' she said, 'but it just looked like one of those pterodactyl things on horror or dinosaur movies. I don't know where it went to, it just seemed to fall right into the ground.'

Funnily enough, Andrea isn't the only person who has had an experience like that. I have no reason to doubt the sincerity of the witnesses I've interviewed – three, to date – but are they really seeing prehistoric creatures? Well, not 'real' ones, obviously. I tactfully asked Andrea if she was a user of recreational substances, as they say. She candidly admitted that she enjoyed an odd spliff, but was adamant that she hadn't smoked cannabis for three days before her encounter. 'I was perfectly sober,' she asserted.

To get to the bottom of the enigma, it may help if I recount a similar experience told to me by a witness from Norwich. Years ago I was asked to travel down to Norwich and address the members of the local Earth Mysteries Research Society on my experiences investigating the weird, the wonderful and the downright spine-tingling. Never one to miss an opportunity to hold court – particularly when the meeting is to be held in an

old inn – I immediately accepted. For nearly an hour and a half I recited a litany of stories about ghosts, UFO sightings and sea monsters, only pausing to drink the glasses of Newcastle Brown Ale which the members were repeatedly *forcing* into my hand (honest). One young chap – not actually a member of the group, as I recall, but simply someone who had turned up to hear my talk – told me that some time ago he went with some friends into the country. After nightfall they suddenly noticed that an eerie silence had descended over the area. Then, to their surprise, a gigantic bird-like creature floated over their heads. I say 'bird-like', as this certainly wasn't a sparrow out looking for a midnight snack or a budgie making a dash for freedom.

'It was about 30ft up,' he said, 'and as soon as we saw it we knew exactly what it was – a fully-grown pterodactyl.' Now before you start making sarky comments about this gentleman's alcohol intake, bear in mind that there were several witnesses to this event. It should also be remembered that, extraordinary though it may seem, reports of pterodactyls are often received in the USA, where some researchers think that it is just possible that a small colony of them may have survived the last few million years unnoticed.

Mind you, although I'd be the first to admit that the concept of a few pterodactyls soaring around in the remoter parts of the Nevada Desert, or wherever, is not impossible, the idea that they may actually have taken up residence near Norwich – and South Tyneside – does seem problematic. Why hadn't they been seen before? What on earth could they be eating? Why haven't we found huge pterodactyl droppings in the park?

My old friend Jon Downes from the Centre for Fortean Zoology believes – as do I – that what these people may have observed is not a 'real' pterodactyl, but rather what, like the Cleadon Panther, is known as a zooform creature. As previously stated, zooform creatures are not flesh-and-blood animals, but spectral beasts that bear a similarity to ghosts and apparitions. They can appear and disappear at will, and are never caught. Their origin and purpose – if they have one – is a mystery, but the number of people who have witnessed them is so great that their testimony cannot be ignored. Maybe, then, Andrea F. was allowed a quick glimpse into the past, catching a scene from a legendary time when giant dinosaurs really did walk the earth and soar through the heavens as well.

CHAPTER 14

ODD COINCIDENCES

Everyone experiences coincidences in their lives. In 2002 I attended a conference on the paranormal in Exeter and discovered that the man sitting next to me at the bar lived only a couple of miles away from my own home. Neither of us had met previously.

Several years ago I was told of another strange coincidence. A colleague of mine was at an exhibition at Newcastle and was approached by a lady who needed some information. My colleague, thinking I could help, gave the lady my name and said, 'I can also give you his telephone number, but I'm afraid I can't give you his address'. 'You don't have to,' replied the lady, 'he's my next-door neighbour.' And so I was.

Of course, coincidences like this occur often and there is nothing inherently strange in them. Most readers will be aware of the old adage that if you give enough monkeys enough time and enough typewriters, eventually one of them will type out the entire works of Shakespeare. But not all coincidences can be explained in this way. A colleague of mine who specialises in studying the phenomenon of synchronicity – the notion that life is filled with meaningful patterns which often repeat themselves – once said to me, 'some coincidences are just too much of a coincidence to be coincidental'. What did he mean? Simply that, from time to time a 'coincidence' occurs which is so extraordinary that it is difficult not to think that there must be some unseen intelligence guiding things behind the scenes.

Let me give you an example. Two men met in an English bar in Spain. They were both from north Yorkshire and both were called Ian Mackins. Whilst discussing this extraordinary circumstance their conversation was overheard by the barman who told them that his surname was Mackens. Not quite the same, but almost. Their amusement was further compounded by the fact that all three men had, during their teens, spent time working as salesmen in the used car trade.

Philosophers and researchers have struggled for centuries to explain this strange phenomenon. One theorist said that such coincidences were not only natural but also inevitable. All of nature, he said, was built upon patterns and rhythms. Tidal ebbs and flows, seasons, daytime and night time. The list is virtually endless. Coincidences, he argued, were simply proof that the same natural forces and laws governed human life and activity. Coincidences were, he believed, simply the patterns of life. An interesting idea, and it may or may not be true. However, what we can say is that extraordinary coincidences add both humour and wonder to our lives.

As we go about our daily business we usually become immune to synchronicity and coincidence. Yet, if we were to consciously take note of these things, we would see that they occur with astonishing regularity. How many times have we telephoned a friend only to hear them say, 'I was just about to ring you'? How many times have we bought

a birthday card for someone, only to find that the recipient has received one or even two identical cards from other people? How many times have we wished to see a favourite film on TV, only to see it appear in the listings a day or two later?

I once received a letter from a Mrs S. Hilton from South Shields, who had read with interest an article I had written on coincidences. It turns out that she had had an experience of her own which was far more extraordinary than any mentioned previously in my column and I couldn't resist sharing it with readers. Mrs Hilton has a sister, and both girls were born almost exactly two years apart. Both were married within six weeks of their twenty-second birthday, and both gave birth to their first child when aged twenty-three years and three months. Incredibly, both of these children were born on 'Pancake Tuesday'. But the coincidences don't stop there. One final piece of information catapults this interesting story into the premier league of extraordinary coincidences. Mrs Hilton's child was born in Tyneside. Her sister's child was born in Bombay. Incredibly, both children were delivered by the same doctor!

Another strange coincidence was related to me by Herbie Calder, from Hebburn. Years ago he went on holiday to Hexham. Whilst walking past a local supermarket he bumped into an old friend whom he'd not seen since childhood. They decided to have lunch together. Within minutes a series of fascinating coincidences became apparent. Both had married women called June. Both Junes had disabilities brought about through riding accidents, and both had sisters called Brenda. Both Herbie and Eric bred and raced pigeons, and both had also managed or worked in public houses. Herbie had managed a pub called the Blue Bell, whilst Eric had worked in a pub named the Blue Boy. Eric had subsequently moved on to another pub called Bell Inn, whilst Herbie worked in an inn called the Black Boy!

Other readers went on to send me their own personal experiences with 'synchronicity'. Jane from Whiteleas told me that both she and her brother had purchased the same make of mobile 'phone on the same day and from the same store. Both had the same fault and had to be returned. (Mind you, this isn't too remarkable, as the entire batch may have been faulty.) Barry from the Nook told me that after graduating from university he started work part time in a pizza parlour in London. The first person to walk through the door and order a pizza was a friend from Centenary Avenue.

Some coincidences that have occurred abroad are no less bizarre. A thief in Washington, USA, fell through a skylight on the roof of a convenience store he was burgling. He landed on top of another thief who was also trying to burgle the premises. Both were found lying on the floor unconscious by the police, and were later jailed. Ah, bless. A corrupt policeman in Kuala Lumpur decided to rob a bank, and in an effort to disguise himself he shaved off his moustache. This may well have worked a treat, but unfortunately his ex-wife was in the queue at the time, recognised him and promptly informed the police who turned up exactly who he was. The man was arrested later, and now he's doing time for his crime. Whether he's re-grown his moustache or not is not recorded. And one tale I've heard – but haven't been able to substantiate – involves a prosecution lawyer from Minnesota who successfully persuaded a jury to send a man down for armed robbery. The accused got twenty years, and the lawyer was later to discover that the man he'd had incarcerated was his long lost brother.

Whilst chewing the cud with an old friend of mine over a pint, I was made privy to an intriguing story. What readers will make of it I know not, but it's certainly worth a

mention. My pal had heard about a chap who had moved house recently, and, during the first few weeks, engaged in some decorating and a bit of DIY. At some point his attention turned to a crack in the wall of the living room and he decided to repair it. Just as he was about to fill in the gap with a large dob of plaster, he noticed a wad of newspaper stuffed inside it. Curious, he prised it out. The paper had yellowed with age and was brittle. Nevertheless, the man was able to unfold it. What he saw stunned him. It contained a photograph that had obviously been taken at a wedding, and it was, in fact, of his own wedding. Staring at him from the page was his younger self and his bride on their wedding day. An extraordinary coincidence? Probably, but the odds against such a thing happening again are truly astronomical. Nevertheless, experiences like this are not uncommon.

Once, a colleague asked me whether I knew anything about an ancient Lakota Sioux Indian story called the Legend of the White Buffalo. A pretty obscure question, you'll grant, but by amazing coincidence I'd started to research the White Buffalo legend myself just two days earlier. However, that wasn't the end of the story. That very afternoon I happened to be browsing around Wilkinson's store in the market square. I glanced up at the large racks where they display their wall posters, and what did I see? A huge poster with the head of a white buffalo on it and underneath the legend itself.

As I continued to publish reader's stories about these amazing coincidences, one correspondent informed me of a curious fact: most medical specialists have a greater susceptibility to the particular disease they treat than the average man in the street. In other words, heart specialists are more likely to succumb to cardiac disease than other doctors, psychiatrists more prone to psychological disorders and so on. I asked a doctor whom I know whether this was true. 'Yes,' he said, 'I've heard this before, although I haven't seen hard proof. I've no reason to disbelieve it, though.' Of course, there may be a logical explanation for all of this, although I must confess I'm struggling to think of one. Perhaps this is just another one of those strange coincidences that make life all the more intriguing.

Here's another. Check out the top row of letter keys on a typewriter keyboard, and you'll see that they read QWERTYUIOP. Before you read the rest of this article, try to find the longest word in the English dictionary that can be made up using only these letters, although you may use each letter more than once. Finished? Good. The chances are that a good number of you are already shaking your heads, amazed to find that the longest word that can be made up from the letters on the top row of a typewriter keyboard is, would you believe it, 'typewriter'.

During the Second World War, an American serviceman called Eugene White was stationed in England for several months. He became friendly with a local couple that he met in a pub and was invited to dinner. To his astonishment he found that the newly married couple were called Hugh and Jean White. One doesn't have to be a rocket scientist to see the extraordinary similarity between the names Eugene White and Hugh/Jean White. Coincidence, or is the Cosmic Joker up to his old tricks again?

Even stranger is the story of three sisters, Mary, Clara and Hilda Goddard, who lived in Birmingham, Wolverhampton and Glasgow respectively. On the 12 December 1962 they each posted a Christmas present to the other two. Each one sent two identical Christmas cakes to the others, each cake being of exactly the same proprietary brand. Each sister thus received two cakes identical to those they had posted. Confused? Not

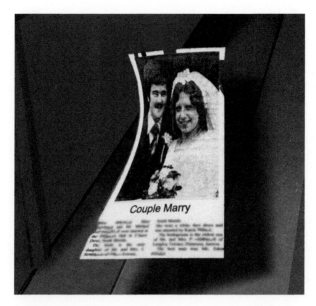

Couple Marry

A Boldon man found an old newspaper cutting stuffed in a crack in a wall – it turned out to be a write-up of his own wedding which had taken place years before. (Artistic representation)

half as much as I am. But there's more. Each of the sisters decided to keep one of the cakes, and pass on the other as a Christmas present. They then proceeded to send one cake each to their cousin, Doreen Latimer, who ended up with three. Worse, Doreen had purchased an identical cake for herself three days earlier.

Perhaps the funniest coincidence I've come across during my research is that of a police inspector called Willie Catcham. He must have been ribbed mercilessly by villains and colleagues alike, poor bloke.

But how can we explain coincidences that seem too extraordinary to be the product of mere chance? It is indeed possible that some form of thought transference is involved, and that, in the case of the three Goddard sisters, two of them picked up the thoughts of the third sister and followed her lead, thus causing all three to send each other the same present.

I was subsequently contacted by two correspondents who related their own eerie coincidences. One of them was called Black and had white skin. The other, who hailed from Nigeria but lived in Hebburn, was called White and had black skin. To top the whole thing off, both were currently employed as furniture salesmen. You just couldn't make it up.

CHAPTER 15

POLTERGEISTS

I once received a letter from a woman in South Shields who had endured a whole series of disturbing incidents at her home for which she has no rational explanation. Clearly worried, she penned a lengthy plea for help. What disturbed her most of all was the fact that she'd received a cryptic message, under extremely bizarre circumstances, which indicated that something terrible may happen either to her or to someone close to her on a specific date.

What I tried to do, through the pages of my column, was put her mind at rest, and also assuage the fears of other readers who may be troubled in a similar way. Mention the word 'poltergeist' to most people and they'll run for the hills. This is because most people believe that a poltergeist is some kind of evil spirit that stalks their home, invisibly, with the sole intention of wreaking havoc. To be honest, this is really the Hollywood movie image of a poltergeist. In reality, a poltergeist is a powerful form of negative energy that can build up in a person when they are under great stress. Hard though it is to believe, this energy can sometimes 'externalise' itself and cause all manner of strange things to happen. People who are subject to poltergeist activity may find objects moving without being touched, hear strange noises when no one is around to make them and, yes, they may also find sinister messages lying around on pieces of paper, or scribbled on walls. Cynics will laugh, but believe me I've investigated enough cases to know that things like this really do happen.

The bottom line is that poltergeists feed on fear. The more anxious and afraid the victim is, the more frequently the poltergeist activity will manifest itself. It is no coincidence, then, that the primary activity of the poltergeist is to instil a sense of morbid dread into its victims.

Recently I dealt with a case where a victim of poltergeist activity who lived in Jarrow received death threats under the weirdest of circumstances. I don't want to go into detail, but the messages simply couldn't have been sent to her by anyone inhabiting the flesh-and-blood world we live in. Did she die? No. The poltergeist merely wanted to frighten her, for only when people become frightened can it sustain itself. Of course, if there is the remotest possibility that this sort of intimidation could be real – that is, actually coming from another person, in which case the police should be called immediately. However, in cases where these messages clearly have a paranormal origin they should simply be ignored.

I know of dozens of cases where poltergeist victims have lived in dread of a certain month, week, day or hour in the belief that some calamity is going to befall them. In truth, the only thing to fear is fear itself. Seeking medical advice is always advisable

Poltergeists will often move objects as if they are being pushed by an invisible hand. (Artistic representation)

under such circumstances. Sometimes it is possible to become so afraid that ordinary incidents can be misinterpreted, and we begin to read sinister meanings into things that aren't really there. Professional help may be needed to help us deal with the stress that is only making the situation worse.

The terrible feelings of dread that plague victims of this phenomenon are real, but in every case I've dealt with the threats have turned out to be empty words. To the reader who wrote me such a heartfelt letter I said only this: seek medical help for your stress, and then write me another letter after the date in question has passed, telling me that you're fine – because I'm sure you will be.

THE BED-SHIFTING POLTERGEIST OF OCEAN ROAD

In April 2001, a reader told me of a ghostly encounter that he had years ago, and one that still disturbs him to this day. The man in question was Bert Tallon, who lived near Horsley Hill. Bert was a retired travelling salesman who moved to South Shields years ago, although he now lives in Eire. At one time, however, he lived in London, and it was during this period that he had occasion to visit South Shields on business.

> I didn't know South Shields very well in those days, back in the 1960s, and decided to look for a bed and breakfast place. I wasn't sure where to start, so I went back to the shop I'd just visited in Ocean Road. The old chap who owned the place was friendly, and I thought he might recommend somewhere. To my surprise, he said there was no need to stay in a B&B as there was a spare room above the shop and I could sleep in it overnight for free. I was grateful, and immediately took him up on the offer.

This was a decision that Bert soon came to regret.

> The room was small, but tidy. The owner showed me where the kettle was kept in case I wanted to make a cup of tea. He also left the back door of the shop unlocked in case I wanted to go out. He said there'd be no problem as long as I shut it firmly and didn't leave it open so that it was obvious to a passing thief. He told me that he'd come back to the shop the following morning at 8.30 with a bacon sandwich for my breakfast. I thanked him for his kindness, and then he left. I settled down to read a book for a while, and then, about eight o'clock, I went out and bought some fish and chips. I hurried straight back to the shop mind you because I was terrified that someone would break in and steal something. That's when the funny things started to happen.

What happened was not really funny ha-ha, although it was certainly funny peculiar. When Bert got back to the shop he found that the temperature had dropped dramatically.

> It was like an ice-box. Suddenly, the bottom of the bed started to lift up off the floor. I could actually see the gap in between the legs and the linoleum. Then they banged down again. Then it happened again, and yet again. The legs just started banging up and down on the floor. It was so violent I thought the bed was going to smash straight through the floorboards. For some reason I wasn't scared. It was as if I still thought that there had to be a rational explanation. I walked over to the bed and jumped on it, thinking that I could force it to the floor and stop the banging. All that happened was that it got ten times worse and I fell onto the floor. I knew then that there was something spooky happening.

Without further hesitation, Bert left the shop. He left a note for the storeowner, making up some excuse for having to leave early. He would rather drive to London overnight than spend another minute in the place. 'I never went back there,' he said. 'The man probably thought I was rude, but I was too frightened. I wonder if he knew that there was something strange about that room, or was it just me?'

WEIRDNESS IN WESTOE VILLAGE

In June 1999, I received a call from a woman who claimed that some extremely disturbing things were going on in her home and things so bizarre that she felt they could have no rational explanation. A reporter took her telephone number and passed it on to me. The following day I rang her and she briefly outlined what had been going on. I asked her to email me with further details and promised to contact her after I'd given the matter some thought.

Melanie (not her real name) told me that she had read my 'spooky column' in the local paper from the beginning. Nevertheless, she had always, she said, been sceptical of stories involving unexplained phenomena, hauntings, UFOs and similar peculiarities. 'I have always believed only in what I can see,' she stated. Until she moved house, that is.

The move went fine. The furniture van turned up on time, nothing got broken in transit and the rain held off until the move was complete. In fact, it wasn't until Melanie began to unpack that she suspected that something was wrong.

At first I thought that it was just me. I would unpack something and then put it down, only to find minutes later that it wasn't there. The first couple of times I just put it down to stress. I was busy, and just thought that I was forgetting where I was putting things. Then I put my food mixer down, and I thought, 'right, I'll definitely remember where I've put that – on the kitchen bench'. Two minutes later it was gone. I know this sounds stupid, but I found it later at the bottom of the garden. I thought I was becoming mental ill.

I felt extremely sorry for this lady. She was obviously distressed, and I agreed to go and see her. Within minutes of arriving it was obvious to me that she was not imagining things. There was, I knew, a poltergeist at work.

The house, a neat terraced house in Westoe Village, looked completely ordinary from the outside. It looked completely ordinary from the inside, too, until I saw the ashtray move. One minute it was sitting motionless on the coffee table. The next it was sliding, as if pushed by an unseen hand, across the varnished wooden surface. It hovered momentarily at the edge of the table, as if unsure whether to take the plunge. Then, as if floating on a cushion of air, it dropped slowly to the floor.

Since I began writing my 'WraithScape' column I have investigated several cases of poltergeist infestation. I have, several times, witnessed objects translocating from one place to another but this was the first time I had actually seen an object begin to move. This may not seem like much, but paranormal investigators are rarely given the privilege of seeing a poltergeist-controlled object begin to move. Usually, the investigator only has his or her attention drawn to the object after it has started its journey from one place to another. Why? I couldn't tell you. Like so many other things connected to the poltergeist phenomenon, it is an enigma.

I talked to Melanie, asking her about her life in general. She told me that she had recently divorced and that she and her daughter had moved to Westoe, determined to start a new life. It also became clear that her daughter was not happy. She was upset about her parents' divorce and also disturbed at the fact that she had been forced to leave her friends behind in Jesmond because of the move.

At this point I began to suspect that Melanie's daughter was the focus of the poltergeist activity. Unlike apparitions, poltergeists are not 'place-centred', rather they are 'people-centred' and cannot be left behind by moving house. Move house to escape a poltergeist and the poltergeist is likely to move with you. I suggested to Melanie that she should spend more time with her daughter, easing her fears over the divorce and suggesting ways in which she could keep in touch with her old friends. After four days the poltergeist activity stopped.

So what was the explanation? I suspected that Melanie's daughter was suffering from both stress and anger due to her parents' divorce and the house move. Subconsciously she was externalising her anger and causing poltergeist phenomena to occur. Incredibly, people who are the focus of poltergeist phenomena do not even realise that they may actually be causing them. The stress and tension they are enduring has to find an outlet, and it does so by initiating the bizarre phenomena which we collectively label as the poltergeist. The poltergeist, then, is not the spirit of a dead person. It is a display of 'mind over matter', or telekinesis, by a depressed and angry person. Once this is understood it is possible to cure the problem by working on the stress and tension that is disrupting the family.

CHAPTER 16

PREDICTIONS AND PROPHECIES

Predictions and prophecies are broadly the same thing, although the former are normally more specific in their content than the latter. Whatever, the world is filled with those who believe they can see into the future. Intriguingly though, many people who don't even realise they have 'the gift' are equally as adept at telling us what the future holds anyway. Good fortune-tellers and bad fortune-tellers – you won't have to look far to find one.

Whilst walking through Sunderland town centre one day, Mrs H. and I saw a young gypsy woman selling sprigs of heather. This brought back fond memories of another Romany, who correctly predicted the publication of my first book years ago. We walked over, purchased the heather, and before you could say Jack Flash I was having my palm read. And I have to say that her accuracy was nothing short of astonishing. In a beautiful Irish brogue she correctly told me that I had three sons, that one of them had gone away to work and that he had landed a really good job. She also told me about several health problems I had encountered, and then – for good measure – repeated word for word exactly what medical advice I'd been given to tackle it.

There is no doubt that gypsies have a genuine gift of 'second sight'. What intrigued me about this woman were her final words: 'God bless you sir. We'll meet again, I can tell you that... and you'll have a happy tale to tell me'. With a broad grin she shook our hands and departed, leaving Mrs H. and I bemused at why gypsies are always given such a negative press. What tale will I be relating to her? Only the future will tell.

BEARERS OF BAD NEWS

In March 2000 yet another letter arrived at the offices of *The Shields Gazette* from a reader who was quite concerned about a fortune-teller who had 'prophesied' that something bad was going to happen to her. Such incidents are not uncommon. What this particular lady wanted to know, however, is whether it was inevitable that the prophecy would come true. Before I answer that question, however, it may be prudent to look at the whole issue of fortune-telling.

First of all, let me state unequivocally that some individuals do seem to have the ability to see into the future. Years ago, when I was still waiting to hear from my publisher as to whether my first book had been accepted for publication, a lovely gypsy

lady knocked at the door. She'd never met me before, and yet she told me that I was a writer, and that I would hear from my publisher within two weeks. She also told me that my book would be accepted for publication, but that I would not make a lot of money from it. Everything she said was perfectly accurate.

Only recently, my parents told me of a similar incident that occurred when I was a child. When I was seven years old we lived in Humbert Street in Jarrow, and one day an elderly gypsy knocked at the door selling pegs. My mother bought some, and then the lady stared at her intently and spoke. 'You have two sons. When they grow up, the younger will hold a paintbrush in his hand and the older a pen.' My younger brother, Graham, is a talented artist and I, as you will no doubt have gathered, make my living by writing. Her prediction was right on the money.

But what about bad prophecies and predictions? The interesting thing is that very few genuine fortune-tellers give out 'doom-and-gloom' predictions to their clients. One told me, 'yes, from time-to-time I do see bad things ahead for those who visit me, but I would never tell them so. It is totally irresponsible to worry people like that. I just tactfully avoid the bad and emphasise the good.'

It is also fair to say that the more you believe in a prediction the more likely it is to come true. One man who visited a fortune-teller, Keiran McLennan, was told sombrely that he would have a heart attack in three months. Two and a half months later he duly had the heart attack and was lucky to survive. But what brought on the seizure? An inevitable meeting with fate? Not according to his wife. 'I am convinced to this day that Keiran willed himself to have the attack. He was obsessed with what the fortune-teller told him. He worried that much about the prediction that the stress made him ill. If you ask me, that's what brought about the heart attack.'

Fraudulent fortune-tellers can be very adept at making you think that they have genuine psychic powers. My wife and I watched incredulously one morning as a well-known TV psychic told a viewer who called the TV station during a 'phone-in programme, 'watch out for February. You're going to meet someone who will say something impolite to you at work. Also, someone in your family will have a mild illness, but they will recover after a few days.' Such prophecies may seem impressive and precise but, let's face it, who amongst us wouldn't have a minor altercation at work during the course of a month? And isn't it true that almost every family will have at least one person in it who will have an ailment of some kind, even if it's just a head cold or an upset stomach?

A lot of the power in a prediction comes from the degree to which it applies to those who believe it. My advice to anyone who has been given a depressing or pessimistic 'prophecy' about their future is to ignore it completely. Our lives are governed by our own actions, and even if fortune-tellers sometimes can see into the future it does not mean that the future cannot be changed.

Genuine fortune-tellers – those like the elderly gypsy ladies both I and my parents I encountered – wouldn't dream of bringing fear and dread into people's lives by telling them that something terrible was going to happen to them. To the lady who wrote me the letter, and others like her, I would say forget what the so-called fortune-teller told you. Concentrate on the rest of your life, which may well be long and happy if you work hard at it.

I was also once asked by a reader whether it is wrong to try and predict the future. This is not an easy question to answer and, depending on the circumstances, a

different response may be given every time. First of all, I think we can say that wanting to know what the future holds is a perfectly normal trait of human nature. In fact, our very lives depend on it. By observing nature's cycles and rhythms we can predict when it will get dark, when it will get light, when the winter will come and even when it will rain. Without our ability to make predictions, the agricultural world would be thrown into chaos.

But, what about predicting the future of individual people? Again, it's perfectly natural to want to know what fate has in store for us. However, there's a danger that we need to watch out for. Imagine that you were a business person and I told you that within six months you were going to become a millionaire. If you really believed me, then you might just sit back and wait for the money to roll in. You may neglect your business, thinking, 'what does it matter? I'm going to be rich anyway!' However, working hard at your business venture may be the very thing that makes you that million. So, by neglecting your business you may actually be doing the very thing that prevents the prediction from coming true!

This is why many American Indians say that it is 'bad medicine' to make predictions like that, for they can lead people to think that they are no longer in control of their destiny. Whenever I'm asked, 'do you predict the future?' my usual answer is, 'no – I don't predict your future, I help you control it'.

An extremely shy gentleman who once wrote to me wanted to know whether he would ever remarry. He had been told that he would, but not in such specific terms. Why? Because he may then have just sat back and waited for his bride-to-be to come looking for him instead of getting out and widening his circle of friends. What the man was told was that the reader could certainly see a relationship developing, but the Tarot cards also indicated that if it was to be a success then he would have to work hard at it. In short, the happiness he sought after was within his own hands, not that of the clairvoyant.

It's funny how easy it is to take things for granted. When I get up in the morning I've been so used to looking in the mirror and seeing a tall, handsome Adonis-type figure with rippling muscles and boyish good looks – a seriously worried Mrs H. suggested that I pay a visit to the opticians, which I duly did (I'll never forgive the good folk at Vision Express in King Street for helping me to see myself as I really am). Seriously though, looking in mirrors as a form of divination has a long history. The *Specularii* in ancient Rome were often called upon to advise Caesar, and in a sense it's not hard to understand why.

In the twenty-first century mirrors are no big deal, but in ancient times people just didn't understand the physics behind light reflecting off a shiny surface and creating a mirror image. Hence, a number of alternative explanations were in circulation. Depending on whom you spoke to, mirror images were demons, ghosts, doppelgangers or guardian angels. In all cases, however, mirror reflections were believed to have a spiritual or psychic origin. In some cultures, such as ancient India and ancient Greece, just seeing your reflection in water was meant to be a harbinger of death.

Scrying is the ancient technique of looking into a mirrored or shiny surface in an effort to divine the future. Ordinary mirrors are useless in this regard for they simply reflect everything around them. However, looking into a crystal ball or a bowl of ink often produces remarkable effects. Nostradamus was a skilled scryer, although the accuracy of his prophecies is a hotly debated subject. Even in our modern era, however, scrying is incredibly popular. So popular, in fact, that I asked a local expert for her thoughts on the subject.

'Scrying' into a mirror is said to be able to help predict one's future.
(Artistic representation)

Scrying is a way of connecting with psychic energies, and it's not for the fainthearted as it can leave you feeling drained. The trick is to stare at the reflective surface with what I would call the third eye and not your physical eyes. At some point you will actually feel bored – and that's when the images will actually start to appear.

Like all techniques for seeing into the future, scrying should be used when necessary and not for whimsical or trivial knowledge. As one diviner said to me, 'the Creator gave us a brain. He gave us wisdom and an intellect to decide our own futures to a large degree. Being frightened to make a move in life without consulting a fortune-teller is distinctly unhealthy.'

People consult clairvoyants and diviners for a variety of reasons, of course. Some do so because they lack the confidence to make their own decisions, others because they want some moral support, to be told that they're doing the right thing. Others do so because they just want some further insight into an aspect of their life, some clarity when their judgement is a little clouded. This is fine. A good reader should actually enhance our self-determination and confidence, not restrict them.

Make your own decisions and control your own life – we make our own destiny most of the time.

THE TWIN TOWERS

Over the millennia many psychics have made prophetic statements about the future. Thank goodness, most of the doom-laden prognostications have never came to pass – well, at least not yet.

On 9 September 2001, a well-respected South Shields clairvoyant, Anna Kaye, told me, and several others, 'I have an awful feeling something terrible is going to happen.

Whatever it is will happen soon, and the whole world will be forced to sit up and take notice.' Two days later, the Twin Towers were deliberately demolished in a day that will live in our memories forever.

Of course, sceptics will say that this was a mere coincidence. After all, the clairvoyant hadn't given any specific details or times. Her prediction could have fitted just about any major disaster. And yet, the close proximity of her prediction to what has now become known as '9/11' is chilling.

Shortly afterwards I received a telephone call from this same clairvoyant. She had experienced another vision in which she saw something terrible happen. This time, she could give specific details. The prediction concerned a terrorist attack, and she felt that the month of December was significant in some way, although she stopped short of saying that the attack would definitely happen in December. The target for the attack, she claimed, would be a major airport in the USA. The clairvoyant mentioned the state in which the airport was located, and, significantly, the name of the airport itself. She also mentioned a unique architectural feature adjacent to the airport. A few minutes roaming around the internet confirmed that every piece of information given to me by the psychic was accurate, even though she has never visited the States and had never heard of the airport in question before. Desperate to warn someone, she telephoned the UK offices of a major US satellite news channel and told her story. 'Not interested,' she was told rather curtly.

The bottom line is that psychics are just not taken seriously by many professional people, who could actually benefit from their assistance. Interestingly, the evidence indicates that when the authorities do enlist the help of psychics startling results can follow. Several murderers have been caught through evidence given to the police by clairvoyants, and the remains of their victims have sometimes been located in the same way. In the USA, a teenage homicide victim was left in a car parked on the top level of a multi-storey car park. Two days after her distraught parents appeared on TV tearfully asking for help in finding their missing daughter, a psychic telephoned the TV company and told the station manager that the girl was dead. But that wasn't all. The woman said that the body was in a blue car, parked at the top of a parking lot and that 'the rear fender has blood on it'. The police searched local car parks and located both the victim and the car. As predicted, there was blood smeared on the rear bumper – and nowhere else. At first the detectives wondered if the psychic had been in on the murder due to the accuracy of her information, but quickly came to see that she was genuine.

To date, Anna Kaye's prediction about a terrorist attack on an airport has yet to be fulfilled. I hope it never is. However, I also hope that the many psychic predictions that have been made regarding terrorist activity will be taken seriously, or at least given some consideration. Blind prejudice should not be allowed to stand in the way of saving lives.

CHAPTER 17

PSYCHIC PHENOMENA

No one fully understands how the human mind works – or its true potential. With every passing year, science is making new discoveries which leave us in awe at how sophisticated our thinking processes are. Since the dawn of time thinking people have believed – or at the very least, suspected – that the mind does not simply influence what goes on inside our head, it can also affect what goes on outside of it. Welcome to the strange world of psychic phenomena.

TOUCH AND SEE – THE INCREDIBLE GIFT OF PSYCHOMETRY

Several years ago, a well-known TV personality hosted a weekly TV show. Each week he would examine different subjects, all of which could generally fall under the heading of 'the paranormal'. The purpose of each show was, seemingly, to look at that week's topic impartially and fairly to see whether there was any truth in it. One week he dealt with UFOs. Another week he examined telepathy. On yet another programme he took an in-depth look at astrology, and so on. Although each programme was supposed to be fair and impartial, I found them to be anything but. Firstly, when the person hosting the programme is an avowed sceptic, what chance is there that it will be objective?

Secondly, some of the 'tests' that the host set up were, in my opinion, almost guaranteed to produce a negative result, although I cannot say for certain that this was the intention. But he didn't get everything his own way. One programme dealt with the subject of psychometry – that is, the ability of some people to discover information about a person just by touching or holding something that belongs to them. On the programme in question, the psychometrist scored a number of stunning 'direct hits'.

I was once informed about a test carried out in Canada where the psychometrist proved to be breathtakingly accurate in her assessment of who the owner of the object was – in this case a watch – giving his first name, his age, his job and the fact that he had recently broken his right leg in a horse-riding accident.

No one really knows how psychometry works. There is no known scientific mechanism by which one person can discover things about another just by touching one of their possessions, but it does work, I can assure you.

A correspondent from the USA told me of a case involving an American psychometrist who was once asked to help solve a murder case when all conventional investigations had failed to come up with any leads. A young boy had been murdered and his body dumped by a roadside. After visiting the spot, the psychometrist asked for one of the

Some people have the ability to sense things about people simply by touching their possessions. (Artistic representation)

dead boy's training shoes which had been found at the scene. After clutching the shoe for a few seconds she said, 'oh dear… this is terrible. I can see a man… he has blonde hair and a moustache… oh… he's hurting him… this is awful… he keeps asking him to stop but he won't. Please make him stop!' Interestingly, the psychometrist mentioned that the man she saw in her vision had a black baseball cap on, and on the front of the cap were the words 'Big Time Team Player'. This startling piece of information was to trap the killer, for the mother of the dead child recognised him as an attendant at a local petrol station. He was blond, moustached, and wore a black baseball cap with those very same words embroidered on the front. The man is now in prison for life.

In another case – which, to be fair, I have not been able to verify despite a fair bit of research – another Canadian psychometrist was apparently given three small bags. In the experiment she was allowed to touch each bag lightly with her little finger, but nothing else. She was not told what was in each bag, and had to determine the contents purely through her psychometric powers. She correctly identified the contents of the first bag as a compass and the contents of the second bag as a marriage certificate. When it came to the third bag, she claimed that it contained a photograph of an astronaut. In fact, it contained a 45 rpm record by Elton John. The title of the song? You've guessed it, *Rocket Man*! This may make you snigger, but psychometrists do sometimes 'get it right whilst getting it wrong at the same time,' as they say. This demonstrates that psychometry is not an exact science. It is, however, an amazing demonstration of the power of the mind – a power which we do not even remotely understand.

I recently got chatting to a reader who said that he had always been cynical about the paranormal. He had, he confessed, thoroughly enjoyed reading tales about monsters, ghosts and little green men from Mars, but always taken them with the proverbial pinch of salt. Until, that is, he had his own experience with the unknown, which, of course, made him re-evaluate his stance rapidly.

In 1998, Mark had bought a cardboard box 'full of junk' for two pounds from a stallholder at South Shields flea market. Inside there were bits of old radios, cutlery and other odds and ends, some of which he thought might come in useful. Several months later, Mark was tidying up – a habit not entirely unknown in the male of the species, despite rumours to the contrary – and decided to go through the jumble in the box. One item caught his eye: a china dinner plate covered in pictures of old steam engines. After he'd finished sorting out the garage he went indoors and gave it a good wash in soapy water. Mark was so taken with the plate he decided to hang it from the wall. He knew that there were some plate hangers in the house somewhere, but he'd have to wait for his wife to return from work so that he could ask her where they were. Meanwhile he placed the plate carefully on the kitchen table and went in the living room to watch a football match on TV.

When Sandra came home, Mark showed her the plate, which was gleaming like a new pin. However, rather than go into raptures over it like her husband, Sandra immediately put it back on the table and stood back. Mark could see by her face that something was wrong. The question was, what?

Sandra said that as soon as she handled the plate she was overwhelmed by an intense feeling of sadness. She couldn't explain why, but she felt as if she could burst into tears. Sandra had never had any psychic experiences before and was alarmed. Mark told her that she had probably just imagined it and suggested that she touch the plate again 'just to prove that it wasn't haunted', as he put it. Sandra placed her hand on the plate, and immediately felt the same, morbid sensation overwhelm her. This time it was more intense, and she also experienced an extremely bitter taste in her mouth.

Mark's aunt, Dorothy, lived only a few doors away and they showed her the plate. According to Mark, his aunt thought the plate was beautiful and stated that she wished she had seen it first as she'd like one like it herself. But then she picked up the plate. According to Mark, she shuddered violently and immediately put it back down. 'Get rid of that plate,' she exclaimed, 'get it out of your house now. I don't know what it is but there's something awful connected with it. I feel sad, as if someone's died.'

Mark said that his aunt's reaction convinced him that his wife hadn't imagined it at all, and he promptly threw the plate in the bin. 'Maybe there really is something in this psychic malarkey,' he told me. No arguments there, Mark.

MESSAGES FROM THE MIND

Back in 1999, 'WraithScape' reader Mary Philips told me a fascinating tale. Twenty years ago, Mary worked in a warehouse that belonged to a well-known mail-order catalogue, and her job was to make sure that all purchased goods were dispatched on time. One evening she finished work and dashed home to make tea, when she suddenly remembered that she had forgotten to give her boss an extremely important message: he had to go into work an hour early the following day as a senior manager was coming to see him at eight o'clock. Mary panicked. She didn't have her boss's telephone number, and she didn't know where he lived. There was no way she could get the message to him in time. Then she remembered something. Her boss had mentioned that he lived next door to a petrol station in Sunderland. If she could find the petrol station she would recognise her boss's car immediately, as it was a distinctive colour

and model. The problem was that Mary couldn't remember which garage it was that her boss lived next door to. All evening she tried desperately to recall the name of the filling station, but to no avail. By nine o'clock in the evening she still couldn't remember, and as every minute ticked by she became increasingly worried. Tomorrow she would be in BIG trouble.

And then the telephone rang. To her amazement and relief it was Mary's boss. For some reason he'd had a strange feeling that Mary had asked him to drop a message in to someone who worked at the filling station next to his house, but he couldn't remember what the message was or who he was supposed to give it to. Stunned, Mary truthfully answered that he must have been mistaken. She didn't know anyone who worked at the garage and certainly hadn't asked her boss to drop a message off there. 'Strange,' said her boss, 'I could have sworn that you did'. As you can imagine, Mary took the opportunity to 'remind' her boss that he had to go into work early the next day. 'Thanks,' he said, 'It must have slipped my mind.' Mary tactfully said nothing, wished her boss goodnight and put down the receiver!

So what had happened here? Why did Mary's manager suddenly get the completely nonsensical idea that she had asked him to take a message to the petrol station next door? The answer may lie in the peculiar phenomenon known as telepathy – that is, the ability to relay messages from your own mind to the mind of a 'receiver' without using conventional means such as speech. We know that a) Mary was concentrating hard on trying to remember where her boss lived, b) she knew his house was next to a filling station and c) she needed to relay an important message to her boss. I believe that somehow Mary telepathically transmitted her thoughts to her boss, who received them, but in a slightly distorted way. The mixed-up messages gave him the impression that Mary had asked *him* to relay a message to someone in the petrol station.

Stressful circumstances can particularly enhance the chances of telepathic communication, and this ability seems especially prevalent between mothers and their children. Often, when a child is in danger or trouble, the mother will suddenly get a feeling that something is wrong. When news is first broadcast of an air disaster, it is also not uncommon for a close relative to watch the broadcast and just 'know' that their husband, son or father was on board. They do not know this objectively, but they do know it intuitively.

The chances are that just about every reader of this book will have had a similar experience at some time or other. If so, then you've seen telepathy at work.

THE PSYCHIC LADDER

Back in February 2002, two readers of my 'WraithScape' column wrote in – independently of each other – and asked if I knew of any simple ways by which we could test our own psychic abilities. The good news is that there are, and I'll now explain just how you can do it. Prepare to be amazed at the powers lying dormant in your own mind.

Some time ago I invented a simple test for assessing your own psychic abilities. It was subsequently published in the press, and was eventually dubbed 'Mike Hallowell's Psychic Ladder'. To make things easy, a copy of the device is printed in this book.

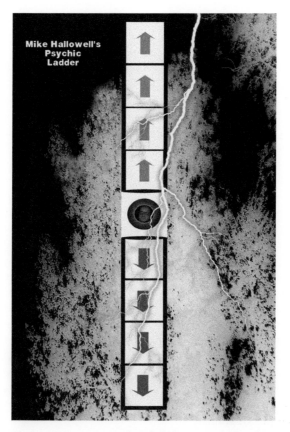

You can hone your psychic skills by using the Psychic Ladder.

You will see that the Psychic Ladder comprises of nine squares – four 'below', four 'above' and one in the centre bearing a circle. Place a penny on the centre circle, and decide whether you want to move the penny up or down the ladder. Your objective is to make the penny 'fall off' either the top or the bottom. Now take a second coin, which you will use for flipping. Heads means that you move the first penny one square up the ladder, tails that you move it one square down.

Now for the important bit. Close your eyes and focus your mind. Visualise my Psychic Ladder in your head, and, mentally or out loud (it doesn't matter which), say either 'move up!' or 'move down!' depending on which direction you want the penny to move in. Now flip the second coin, and move the first coin accordingly. At first the penny may just seem to move up and down at random, and on occasion the penny may 'fall off' the wrong end. Don't worry! The more you practice and the greater your self-belief, the more successful you will be in moving the coin to the end of the ladder that you chose.

Try making your own Psychic Ladder, comprising of twenty or more squares. Intriguingly, those who are just beginning to use the ladder tend to do better with large ladders than small ones. Keep a record of the number of successes you have. Believe me,

providing that you focus your mind correctly you *will* influence the coin to move in the direction that you want it to, and your successes will always outnumber your failures.

Here's another experiment. Ask a friend to sit down on a dining chair, and stand between 6ft and 10ft behind them. Tell your friend that you are going to 'will' them to turn their head to either the left or the right. When you are ready, focus on the back of the person's head with your eyes, and imagine either the word 'left' or 'right' flowing from your eyes and into their mind. Then say the word 'now!' out loud, at which point your friend should turn their head, at random, either to the left or the right. With practice and the right amount of mental discipline you will be able to make your friend turn their head in the direction you want them to, much more than the opposite direction.

THE MILK OF HUMAN KINDNESS

Back in 2003, the local press broke the story of how the aforementioned well-known clairvoyant and medium Anna Kaye mislaid a lottery ticket that would, had she been able to find it, netted her something in excess of £3,000,000. The story was handled sensitively, some reporters even praising her stoicism when she philosophically admitted, 'what you've never had you never miss'. The gutter-press tabloids were not so kind, leading with headlines such as 'Mystic Mug' and 'Dippy Psychic'. Nasty. They certainly know how to kick someone when they're down.

Let me tell you a few things about Anna. She is a decent, kind human being who never has a bad word to say about anyone. In fact, on the day she bought the ticket she was working at a charity event for which she received not a penny, even by way of expenses. I was there too, and can testify that Anna *did* indeed buy a lottery ticket. Anna is making no excuses for the fact that she lost both the ticket and the £3,000,000 it was worth, but why was she vilified in such a scurrilous manner by the press? In a sense, Anna was an irresistible target. She is a psychic, so why could she not simply use her mystical powers to locate the missing ticket? Indeed, why did she not use those same powers to identify the winning numbers before the lottery was even drawn? As Anna has pointed out, if it was that simple there'd be a lot of rich clairvoyants around. But it's *not* that simple. All the decent psychics I know steadfastly refuse to use their abilities for personal gain. Those who do are usually treated with contempt and their efforts normally come to nought anyway.

Psychics and clairvoyants aren't perfect. They are subject to the same failings and weaknesses, including forgetfulness and absent-mindedness, as every other person. The fact that the tabloids suggest it should be otherwise tells you more about the stupidity of their so-called journalists than it does about the nature of psychic phenomena. Instead of sympathising with Anna Kaye, they kicked her in the teeth. There again, trash-mongering scribblers who take great delight in ridiculing someone know that their contemptuous efforts will sell more papers.

Anna survived this sad episode in her life and those who knew her were incredibly supportive. The irony is that had she found the ticket and claimed her money she'd have given bucketfuls of it away to charity anyway. That's just the sort of person she is.

CHAPTER **18**

TIME SLIPS

Is it possible to travel through time? Will 'chrononauts' (the correct epithet for all respectable time-travellers, apparently) eventually be able to journey back through the ages and relive our planet's most exciting times? Could we witness once again the age of the dinosaurs, the sacking of Rome, the American War of Independence and the arrival of the first ducks at the pond in the South Marine Park?

When it comes to working out the scientific pros and cons, I'm afraid I'm not up to muster. Quantum physics and Einstein's Theory of Relativity were never my strong points – I didn't pass my Eleven Plus until I was forty-three – but I'm not sure that science is the best road forward anyway.

Past life regression is one popular means, some say, of accessing the past. Hypnotised persons can be regressed into what some call a past life or previous incarnation. I've been 'regressed' myself, and the experience was amazing. However, whether I was experiencing one of 'my own' past lives or simply experiencing the life of some other person who died many generations ago I don't really know. Not everyone needs to be 'regressed' into a past era, however. Some people have seemingly time-travelled without even realising what was happening.

Some years ago, Lydia Craig told me about a strange, time-travelling experience she'd had as a child. Her grandparents had taken her to a small village in the countryside for a week's holiday, and it wasn't long before she became bored with the country cottage she'd been staying in and decided to do some exploring. There were three shops in the village: a general dealer, a post office and a small dairy outlet next to a nearby farm. As the youngster familiarised herself with her new surroundings, she visited each shop in turn. She particularly liked the dairy shop and was engaged in a lengthy conversation by the old woman who ran it. 'She gave me a glass of milk – the best I'd ever tasted,' she told me. The next day she went to visit the shop again, but couldn't find it. Puzzled, she asked her grandmother where the shop was, only to be told that the old dairy had been pulled down during the First World War.

Had she travelled back in time? It's tempting to believe so.

A ROMAN IN THE GLOAMIN'

Some years ago, a former colleague of mine told me of a strange experience he'd had whilst walking near the Arbeia Roman Fort in South Shields. One Sunday morning, whilst walking down Fort Street he turned and looked through the iron railings which fence Arbeia off from the pavement. Suddenly, he had an overpowering feeling that he

A visitor to the Arbeia Roman Fort in South Shields felt as if he was being watched, even though there was no one else there.

was being watched. Strangely, he seemed to know where the person who was watching him was standing – in amongst the ruins – and yet there was no one there. Other people who have visited ancient sites also report such feelings, and sometimes they may actually find themselves transported through time and able to witness events which transpired hundreds or even thousands of years ago.

The Treasury House in York is famous for producing 'time slips' involving Roman soldiers who were once stationed there. Engineer Harry Martindale had one of the most terrifying encounters of all. Whilst working in the cellar of the building, on his own, Harry was astonished to hear a trumpet call. Then, to his amazement, a solid figure dressed in Roman military garb walked out of the wall in front of him. The apparition was that of a soldier wearing a tunic and carrying a round shield. Terrified, Harry ran to the corner of the cellar and cowered down, watching in astonishment as the first figure was then followed by an officer on horseback and a procession of legionnaires. As this procession walked through the cellar, Harry noticed that they were only visible from the thigh upwards. It was as if the legionnaires were walking on a surface at least 2ft below the current level of the cellar floor. Martindale later speculated that they were walking on the surface of an old Roman road directly underneath the Treasury House, and it is now known that such a road did indeed exist. Intriguingly, sceptics poured scorn on Harry's story, arguing that Roman legionnaires did not carry circular shields. However, it is now known that at least one legion stationed at York, the VI Victrix, was supported by auxiliary soldiers, and auxiliary soldiers carried circular shields!

One timeslip case involved a lady who opened her bathroom door, only to find herself staring at the long-dead previous occupant as he got out of the bath! Somehow, she had travelled back in time and was seeing the bathroom – and the previous tenant – as they were during the 1950s. In a blind panic she shut the door and opened it again, only to find everything back to normal.

No one really knows what causes time slips. Philosophers and scientists alike talk of 'tears in the fabric of the universe' and 'holes in the space-time continuum', whatever they mean. The bottom line is that something causes them, and maybe one day we'll find out what it is.

Oh, and next time you're visiting the Roman fort on the Lawe Top, make doubly sure that the legionnaire you're talking to is just a volunteer dressed up in a suit. Who knows, maybe he'll be a real Roman soldier who just happens to be in the right place at the wrong time.

GONE BUT NOT FORGOTTEN

The idea of travelling through time has fascinated mankind for a very long time, and yet whilst most scientists agree that it is a wonderful idea, there is real doubt that it could ever be accomplished. Most people understand time in the 'linear' sense – that is, that time proceeds in a straight line, every single event following on neatly from the one that preceded it. This view of time is deceptively simple, but it is unlikely to be correct. Quantum physics and other 'new' sciences are forcing us to re-evaluate how we understand time.

Take the way we separate things into 'past, present and future', for example. This is a neat way of ordering our lives but it is a fantasy. As one philosopher said, 'the only true reality is the past. The future has not occurred yet, at least to us, and the present is only a microsecond pinned to the tail of the future. Therefore, the only true reality is the past.' But even this idea is being questioned. Many researchers now believe that the past, present and future are all taking place simultaneously. In other words, in an alternate dimension Moses is still leading his people out of Egypt, British soldiers are still fighting in the muddy trenches of the Somme and someone is taking the first step onto the planet Mars. Some scientists even think it is possible to 'bend' time, so that we may pass from one era to another in a split second. Even if this were true, however, no one knows how to build the equipment to make it happen.

But there may be an easier way to travel through time. If we forget about the scientific approach, we can consider the possibility that the human mind may be able to travel back through time by a process yet unknown to us. Some researchers think that when we die our memories and thoughts are stored in a vast field or databank of information, and that when we die others can tap into it. This 'collective consciousness' may be what we tap into when we go through the process of hypnotic regression. We may not actually be experiencing a previous life of our own, but simply experiencing the memories of someone who died centuries ago.

STRANGE DISAPPEARANCES

For thousands of years there have been reports of people who suddenly disappeared into thin air without trace. On one occasion, an American family was walking through a small wood near their home when one of the children – a four-year-old boy – stumbled and fell. His parents, grandparents, brothers and sisters were just 6ft behind him as they walked down a path. As he tumbled he was obscured for a split second by the large

Gill Smith saw a man suddenly disappear in a wine bar in South Shields. (Artistic representation)

trunk of an oak tree. As his mother and father bent down to pick him up they were astonished to find that he wasn't there. A huge search was carried out, but the child was never seen again; he hadn't fallen down a hole or run off. He is still officially listed as a missing person.

Gill Smith, a forensic analyst from Cleadon, told me about a weird encounter he had back in the 1980s.

> I'd been out clubbing in South Shields, and we ended up in this wine bar. The place was heaving. I happened to turn around and look for my friend, who had gone to the loo and seemed to be taking ages. Suddenly I saw this bloke standing nearby, but he just suddenly seemed to come out of nowhere. He looked scared to death. He was glancing around him as if he didn't know where he was. Then he just shimmered and faded away. It completely freaked me out. I definitely don't think it was a ghost. To me it looked like somebody from *Star Trek* 'beaming down' or whatever. To this day I have no explanation for what happened.

So what happens to people who disappear (or appear) so mysteriously? Perhaps they have experienced what most of us only dream about: time travel.

CHAPTER 19

UFOS

Back in 1998, there were some extremely odd goings-on in the skies over the Marsden area. By all accounts, flashing lights and silvery disc-shaped objects had been putting in an appearance and raising the eyebrows of quite a few locals. I was even told that one chap, again at Marsden, bumped into a rather peculiar creature which he was convinced was an alien. The creature's silver, one-piece space suit was just one of several indications that he hailed from somewhere slightly father away than Souter Point lighthouse.

The thought of aliens wandering around Marsden Bay saying 'take me to your leader' may make the cynics out there laugh hysterically. After all, if a flying saucer was going to land anywhere it would probably be the White House lawn and not the Marsden Grotto car park.

But who knows? There's nowt stranger than folk and particularly alien folk.

THE MARSDEN LIGHT

On Wednesday 27 May 1998, Carl Thomason and his girlfriend Mandi were walking along Marsden beach. With them were Mandi's two children from a previous marriage, aged two and six. At 6.25pm Carl asked Mandi if she wanted to get some fish and chips. Mandi agreed, and so they turned round and headed back to the car park beyond which lay a fast food kiosk. It was then that Carl noticed something strange.

According to Carl the sky was dotted with clouds, but not covered. Being the cynical soul that I am, I checked this out with the Met. Office headquarters in Bracknell, Berkshire, and was told that his description had indeed been correct and matched the weather conditions of the time: bright, sunny, and some clouds. It was through one of the breaks in the cloud that Carl saw, to his amazement, what he claims was a UFO. 'At first I thought it was a helicopter,' he said, 'but the longer I watched it the more I realised it couldn't be. It was totally motionless and there was no sign of rotor-blades. It was just a silvery-coloured ball hanging in the sky.' Carl had pointed out the strange object to Mandi, who had laughed and said, 'Maybe it's a flying saucer!'

I asked Carl how big the object appeared to be. He thought for a moment and then said, 'probably as big as a grain of rice held at arm's length'. Later, I actually held a grain of rice at arm's length to make a comparison and was surprised how large it appeared, comparatively speaking. According to both Carl and Mandi the object 'just hung there' for a few minutes and then shot off in a southerly direction at break-neck speed.

A South Shields couple saw a strange light over Marsden Bay whilst out walking.

Well, did Carl and Mandi see a UFO? The short answer is that we can't be sure. Although there is no doubt in my mind that they saw something they genuinely couldn't explain, that doesn't mean that no natural explanation is available. An aircraft travelling towards you at a distance, for instance, can actually appear as if it is standing still until it gets quite close. If that aircraft then suddenly increases speed and changes direction, it can look remarkably like a static object suddenly 'shooting off' across the sky, and I initially suspected that this was what had happened to Carl and Mandi.

But, what about the fact that the object apparently hung motionless in the sky for several minutes? Unfortunately, the human brain is not very good at judging time, particularly when under stress. Seconds can actually seem like minutes. As an experiment, try setting your alarm clock to go off in three minutes. Then turn away from the clock. Believe me, that three-minute wait will seem like an eternity. On the other hand, if you were to try and complete a task that normally takes five or six minutes within the space of three minutes, the time would simply fly by. This is because our judgement of how quickly time passes is affected by what we are doing at the time. In all probability, when Carl thought he was staring at the object for several minutes, less than a minute may have actually passed by.

Although I believe that Carl and Mandi's experience probably has a natural explanation, that doesn't mean that all UFO reports can be dismissed as easily. Some sightings are just so bizarre that one is forced to conclude that either a genuine encounter with denizens from another world has occurred, or the witness has been subject to some powerful, psychological process such as a hallucination.

Sceptics just love dismissing UFO sightings as hallucinations. It is a quick, convenient way of rejecting something which makes them feel uncomfortable. The problem is that some UFO sightings are witnessed by several people at the same time. Some sceptics

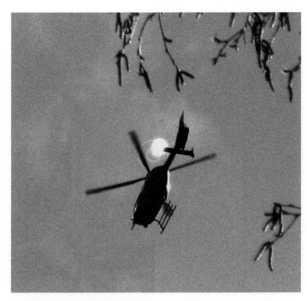

Strange black helicopters were seen flying over Cleadon
Village in 1999.

will then try to say that a mass hallucination may have taken place. This is really just replacing one mystery with another, for no one has ever satisfactorily explained the scientific mechanism by which mass hallucinations occur, and many researchers would actually doubt that such a phenomenon exists at all.

In the United States of America, UFO sightings are often made in tandem with another mysterious phenomenon, the black helicopter. Mystery helicopters, which are painted totally black and bear no markings are being seen with increasing frequency. Despite great efforts, no one has been able to ascertain where they come from or what their purpose is. There is, however, little doubt that they exist, for they have been both filmed and photographed. Most researchers are confident that they are tied up with the UFO mystery.

South Tyneside UFO buffs thought that they had their very own black helicopter just one week after Carl and Mandi sighted their strange object over the coast. A mysterious helicopter was seen flying backwards and forwards across the borough, and several of my contacts seemed convinced that The Big Invasion was about to take place. Alas, it was all just wind and hot water. A local newspaper revealed on 5 June of that year that the helicopter was taking part in Operation Ardent, a military training exercise being held at Otterburn, Northumberland. It was not a black helicopter and it was not chasing UFOs. However, another informant tells me that he saw no less than two black helicopters flying over Cleadon Hills at dawn one day in March, so the mystery may not be entirely solved just yet.

The UFO enigma is one of the most enduring puzzles within the world of paranormal phenomena. They have been photographed. They have been filmed. Many people are now convinced that at least one UFO has been captured and spirited away to the top-secret research establishment in Nevada known as Area 51.

It's easy to snigger at the idea that alien spacecraft may be whizzing across the skies, but those who have witnessed UFOs may yet have the last laugh. A group of very high-powered American citizens – including military personnel and at least one former astronaut – is currently lobbying the US government, demanding that they be released from their vow of secrecy. Why? Because they want to reveal what they know about the UFO mystery to the world. Insiders say that the beans they want to spill will 'blow our minds'. Keep watching the news, then.

ALICE AND THE ALIENS

Alice was thirty-three years old when she began having panic attacks. They were always the same. She would wake up in the middle of the night, sweating profusely with her heart pumping like a steam-hammer. For several minutes she would experience a terrible feeling of 'vulnerability', as if someone was watching her. Then, after a while, the feeling would disappear and she would go back to sleep.

Then, one morning, Alice noticed blood on her pillow. She appeared to have had a small nosebleed during the night. However, as she made her bed she noticed some more blood on the sheets. Examining her left leg, she found a peculiar 'scoop-mark' which looked as if a small amount of flesh had been cut out of her shin with a sharp instrument. Even more bizarrely, her husband noticed that a perfect circle of hair – about the size of a twenty-pence piece – had been removed from her scalp just above her right ear.

Alice visited the doctor and told him that she believed she was having a nervous breakdown. However, she also told him that she was confused, for if these strange happenings were 'all in the mind' how did she have the physical scars to prove that they were really happening? The doctor told Alice not to worry. The hair loss was simply alopecia caused by stress. The nosebleeds and shin wound? 'Maybe you had a restless night and were tossing and turning. You may have banged your nose with your hand and caught your leg with a toe-nail on your other foot.'

All very plausible, except that none of this explained the most frightening aspect of Alice's experience, which she related as follows:

> One morning I woke up and had a strange feeling that something was wrong, but I didn't know what. Then I sat up in bed and suddenly realised that I was wearing a brassiere under my nightdress – something which I never do. The worst thing was that it wasn't even mine. It was this horrible, tan-coloured frumpy thing which was about three sizes too big. I could even smell perfume or deodorant on it which wasn't mine. I just began to scream. It frightened the life out of my husband, who was still sleeping.

Alice's husband Ian happened to mention what was happening to a close friend who worked in the same office. This friend suggested that Alice may not be going through a breakdown at all and may in fact have been abducted by aliens. At first Ian thought this was ridiculous and actually shouted at his friend. 'I was angry that my wife was having a mental breakdown, and here was a supposed friend making jokes about it.' But Ian's friend wasn't joking, and urged Ian to take Alice to a hypnotherapist.

Ten days later, Alice was lying on a couch in the therapist's studio in a deep hypnotic trance. Gently, the hypnotist took Alice back to her childhood in an effort to discover

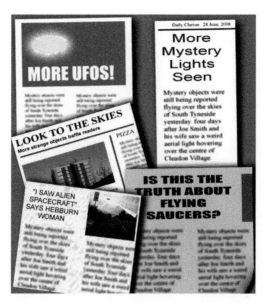

Newspapers in Tyneside have been reporting UFO sightings for decades.

what may have been causing her weird experiences. No one – not the therapist, not Ian or even Alice herself – could have imagined what she would recall.

At the age of eight, Alice remembered playing in a field near her home. Suddenly, the sky 'went sort of dark'. After a pause, she continued. 'There are some men. Funny little men. I don't like them. They want me to go with them on their rocket and I don't want to. I want to go home.' The hypnotist asked Alice to describe the men. 'They're kind of small with grey skin like an elephant. They have real big eyes and they're black. They go right around their head. I don't like them 'cause they stare and stuff.'

Next, Alice recalled being strapped to an examination table inside the craft and then having a blue light shone in her eyes from a machine that made a strange swishing noise. Her next recollection was of being back in the field and hearing her mother call for her.

Further hypnotic regression sessions showed that these creatures had abducted Alice on at least nine separate occasions. Then, when Alice was eighteen years old, the phenomenon stopped, only to start again when she was thirty-three. Once again, Alice was being taken on board a spaceship of some kind and subjected to various 'tests'.

In one session she recalled having a probe inserted in her left nostril. Whilst this was happening she was also aware that another one of the creatures was doing something to one of her legs. As the hypnotist led her through the experience Alice suddenly shouted, 'Ow! He's hurting my leg! Make him stop!'

Finally, Alice recalled being kept in a room with about twelve other people. They were all naked. Dimly she remembered 'the aliens' dressing her before returning her to her bed. This, she believes, is where a mistake was made and she was accidentally given the brassiere of another abduction victim in the same room. Alice is not the first 'alien abductee' to claim that they were returned home wearing the wrong apparel. Actually,

I've heard of several cases in which abductees have been returned to their homes with the wrong apparel, and I've investigated two personally.

Initially derided as the fantasies of a disturbed personality, the alien abduction phenomenon is now being taken very seriously by some respected scientists and experts. Some of these experts have now stated, publicly, that these frightening experiences may not be 'all in the mind', and that physical evidence exists to prove that the victims really have been abducted by beings from another world or a different dimension.

ANOTHER LIGHT OVER MARSDEN

On Tuesday 10 August 1999, Andrew White reported in a local paper how both Jennifer Fettis and Sue Callender witnessed a mysterious shimmering light hovering in the sky over the Marsden area. From the viewpoint of a professional UFO researcher the sighting was very interesting indeed. However, we must remember that not all mysterious objects in the sky are alien spacecraft from the far side of the galaxy. In fact, most UFOs turn out to have a conventional explanation.

The object seen by Sue and Jennifer is a classic case of what UFO experts call a nocturnal light. Actually, nocturnal lights are the most commonly sighted type of UFO and normally display common characteristics. These include 'bobbing and weaving', 'dancing' in the sky or 'wobbling and pulsing'. As in this case, they also have a habit of suddenly shooting off at high speed or disappearing.

Common objects which are mistaken for intelligently controlled spacecraft include stars and planets, aircraft, meteors and re-entering spacecraft or satellites, fixed ground lights, flares and window reflections. Another common problem researchers encounter is that those who witness nocturnal lights will almost always describe them as 'moving around', 'bobbing up and down' or 'swaying from side to side'. In fact, in most cases the object is not actually moving at all but simply displaying what researchers call 'artificial motion'. This is when an object gives the appearance of movement but is actually stationary.

The most common cause of artificial motion is autokinesis. This happens when the witness stares at a bright light in the sky without having any other objects in their view to act as reference points. The object will suddenly appear to wander around. What in fact is happening is that the eye is experiencing small, involuntary muscular movements which the witness is unaware of. It is actually the eye that is moving and not the light.

Another cause of artificial motion is atmospheric conditions. It is not uncommon for light from an object – normally a planet or star – to be refracted. The problem is that each colour is of a different wavelength and may be refracted at a different angle. This can give not only the impression of motion but also of rotation.

Video evidence can also be deceptive. If the frame has nothing in it but the nocturnal light, the object may suddenly seem to move away at high speed. However, it could also be that the camera has been moved away at high speed from the object!

As a professional UFO researcher I have contacts in the field very experienced at video and photographic analysis. It would be interesting to have the footage scrutinised, but even though I haven't seen it myself there is, I think, a degree of circumstantial evidence to suggest it is genuine. I have actually located an additional witness who verifies that the object did indeed take off at high speed just as the film seems to indicate.

Tom Gill is a former pupil of Boldon School, and one morning – he thinks it was in 1994, although he can't be sure – he was walking with some friends to the school site when he witnessed something quite extraordinary.

My mates and I were walking to school when we noticed a silver object in the sky manoeuvring around a passenger aircraft – or at least it appeared to be, admittedly it could have been flying at a higher or lower altitude. It made some sharply-angled direction changes and then flew off to a different location in the sky. Just then it burst into a white light, as if exploding. Once the light subsided we could see that there were now two objects. They appeared to be rounded at one end and slightly pointed at the other. One of the objects remained static, but the other returned to its previous location by the aircraft and continued manoeuvring around it. The static object flashed red and disappeared, leaving a small jet stream similar to that seen behind normal aircraft. However, it was not a trailing stream. It was very short, as if gradually reaching speeds that were so fast it would not leave a stream any longer. A short time later, the manoeuvring object flashed red and did the same thing. At the time we were standing in the park near the old Co-op buildings across the road from ASDA, which we used to call ASDA Park. We were looking toward ASDA at the time, and I believe the objects flew off in a southerly direction, although I can't be sure. Remember, I was only fourteen at the time. The entire event lasted approximately twenty minutes and was witnessed by myself and three other friends. Later we found out that another friend had seen the same thing when he'd been standing at the bottom of Albert Edward Terrace, near the River Don footpath. I was late for school that morning, and received detention as a consequence. I don't know what it was I saw, whether it was something from another world, or whatever, but I do know that I've never seen anything that can fly in such a manner as that craft did to this day. It was very strange – and well worth the detention I received for being late.

Tom's story rung a bell with me, and I checked back through my archives and found that a very similar incident had been witnessed in 1999. The strange craft were almost identical in shape and colour, the only difference being that in the 1999 incident there were four UFOs, not two.

But here's the really curious thing, in the 1999 incident the witnesses were actually standing next to Boldon ASDA at the time. Who knows, maybe the inhabitants of far-flung galaxies like to do their shopping there. Seriously though, witnessing events such as this can have a profound effect on people. To be confronted by something that is truly inexplicable makes one wonder whether we really know as much about the universe and its contents as we'd like to think.

CHAPTER 20

UNDERGROUND RACES AND MYSTERY TUNNELS

A reader of my 'WraithScape' column contacted me with a fascinating story which must be one of the strangest I've ever related.

Bede Wilson, of The Nook, says that his late father told him a story about a series of mysterious tunnels that ran under the school he used to attend. Bede's father claimed that he actually wandered through these tunnels, which could be accessed under the stage in the school hall via a secret hatch. These huge underground spaces were, he says, filled with houses, roads and shops! Now this all sounds like stuff and nonsense, but we should be careful about filing the story away in the box marked 'schoolboy yarns'. Something seemed to tell me that I'd heard this or a similar story before.

Trawling through my archives, I came across two similar stories. One was from the year 2000, when a correspondent claimed that the same mysterious underground dwellings ran from Mortimer Road School to the Cleadon Water Tower. Amazingly, these spacious caverns were apparently filled with streets, houses, shops, stables and vehicles. In short, there was a ghost town right beneath our feet! I'd heard of this tale from a number of sources, and it was said that everything in the tunnels was supposedly of Second World War vintage. Intriguingly, this description tallies with that given by Bede Wilson's father, who told him that the place seemed like a normal town, except nobody lived there. Mr Wilson described 'street lamps, an old-fashioned chemist shop and a stationers, along with many other buildings'. Bede Wilson says that he can't remember which school his father went to, but thinks that it was either Mortimer Road or Harton.

Could there be any truth in this fantastic tale? It's not impossible. The existence of underground bases and bunkers in this country has been well documented, and, indeed, books have been written about them. Perhaps such a complex lies under South Shields, built during the last war as a secret base of operations should we have been invaded by Germany.

Bede says that his father described the underground village as 'Victorian', and remembered seeing a milliner's shop with top hats in the window. This would hardly be classed as vital equipment for an underground bunker during a war. This leaves the possibility that the underground village was something far stranger. Was it built in secret by a wealthy Victorian landowner, perhaps as a place of refuge during the Second Coming? Who knows?

Mind you, how it could have been built without anyone hearing about it is another mystery. If such a secret world does exist, just beneath our feet, then I for one want to go and have a look at it.

UNDER THE SEA

Several times in my column I've mentioned a network of mysterious tunnels which is supposed to lie under the bed of the North Sea, about eight miles or so off the coast of South Shields. Readers have suggested several explanations, everything from natural fissures to ancient, lost civilisations. After running the story I received a fascinating letter from Alex Fowlie, a retired electrician who lives in South Shields:

> I worked at Whitburn [colliery] from 1953 until it closed and knew the tunnel very well; as an electrician I examined a pump in it every week. The tunnel was used when water broke into No.50 Face in the East Drift. It took months to pump the water away so that further excavations could be done in the tunnel. Yes, it was definitely man-made – a beautiful Y-shaped brick junction with little brick, arched refuge holes. It was a work of art. It was similar to other brick archways in old roadways near No.1 shaft. The National Coal Board took photographs of it. There was supposed to be two of these roadways called 'The Commissioner's Headings'. A colliery Overman who I worked for told me they were used for working a small seam of smokeless coal used for ships in the First World War. Those tunnels were the scourge of Whitburn Colliery; they flooded and finished No.50 Face, and in later years flooded out another new area about half a mile further out just before the colliery closed.

So why did the NCB, or anyone else for that matter, not have records of those tunnels and plans detailing their layout? It seems that they may have been dug in a hurry because of the war effort, and in their haste to mine the coal the authorities dispensed with proper record keeping.

But several mysteries still remain. If the tunnels were dug in such a hurry, why was so much time and effort spent in giving them a lavish appearance? The tunnels obviously had some significance, hence the NCB's desire to photograph them and have them properly excavated. Where are those photographs now? We simply don't know, but it would be fantastic if they actually turned up.

A TUNNEL UNDER THE TYNE

One of the strangest – and yet most persistent – stories about underground passageways is that a long tunnel actually stretches from Marsden Bay, under the river Tyne and terminates at Tynemouth Priory. The novelist Catherine Cookson alluded to this tunnel, cryptically, in at least two of her books.

But if such a tunnel does exist, who could have built it and what could its purpose have been? During the eighteenth and nineteenth centuries the infamous Press Gangs often excavated tunnels which led directly to the docks. Victims of the Pressers – usually after having been duped into accepting 'the Queen's (or King's) shilling' – would often

A tunnel is believed to run from Cleadon Village to Tynemouth Priory on the other side of the River Tyne.

be knocked unconscious and taken directly to a waiting ship by means of these tunnels before the local populace could muster themselves and attempt a rescue.

Sunderland writer Alan Tedder has detailed the history of such tunnel complexes in his book *Ghosts, Myths & Legends of Sunderland*[1]. Some subterranean passages, however, were created long before the Press Gangs came into existence. These were sometimes excavated by Catholics, desperately trying to escape the victimisation and persecution of that bigoted matricidal maniac Henry VIII. Catholic priests, in fear of their lives, would often be spirited from one location to another via these tunnels to confuse the authorities.

During the Civil War, there were times when the north side of the Tyne was in Royalist hands whilst the south side was controlled by the Parliamentarians. In such circumstances, the value of a secret tunnel under the Tyne to fleeing Catholics becomes obvious.

Interestingly, similar stories about underground passageways are still in circulation in Tynemouth and North Shields to this day. Tynemouth Priory is alleged to house a tunnel entrance situated near the ruins. During the Suppression, did priests use this escape route to safety when they needed to make a quick getaway? Did they really follow a hidden tunnel to the other side of the river? We may never know.

Some people have expressed doubts about whether those in past times actually possessed the engineering skills to accomplish such a feat, but we cannot discount the

1. Tedder, Alan, *Ghosts, Myths & Legends of Sunderland* (People's Press, 1992)

possibility altogether. Archaeologists are continually amazed at just how sophisticated some 'primitive' civilisations really were.

There is a growing body of evidence that in South Tyneside a large number of underground passageways have been excavated over a period of at least several centuries.

UNDERGROUND RACES

Whilst the discussion over the mystery tunnels was at its height, someone emailed me with an interesting question. Had I heard rumours that a race of strange beings was supposedly living underground in America, and, if so, who, or what, are they?

Actually, whole books have been written about this subject and more will undoubtedly follow. The idea that the ground under our feet may actually be nothing more than a roof, and that under it is another world filled with strange, humanoid creatures, is not new. The American Indians have long believed in such beings, referring to them as 'subterraneans', or 'underworlders'. Ancient Tibetans also believed in the existence of a mystical place, where humans have sometimes strayed to but rarely, if ever, returned from. From Africa to Australasia, the same tales reoccur.

Over the years people claim to have met with these denizens of the underworld. Some portray them as the survivors of the destruction of Atlantis. Others say they are aliens who are secretly building underground bases before finally taking over the earth. Yet others say they are simply a branch of the human race that decided to keep itself secret from the rest of humanity, leaving the 'upper world' millennia ago because they were tired of seeing mankind continually at war.

Could such a place really exist? Well, it's not impossible. All over the world there are vast networks of caves and tunnels under the ground which make the London tube network look positively minuscule by comparison. Yet the big problem that an underground race of people would face is not space, but survival. How could such a race live without sunlight? Artificial lighting, perhaps? Or maybe their physiology is so different they don't need light at all. Food would also be a major problem. There is no conceivable way that a large number of people could live underground unless they had a ready supply of nourishment. Either they grow their food in remote parts of the world that are as yet unexplored, or they have vast underground hydroponic systems where plants can be grown under artificial conditions.

And yet, stories persist of people who have stumbled upon this underground world by accident. Author Timothy Good wrote a book called *Alien Base*[2] in which he proposes that at least some subterranean dwellers are aliens from outer space. It is easy to take such tales with a pinch of salt, but the evidence Good puts forward is impressive. One US military commander said that the content of Good's book was 'deeply disturbing'.

Britain is said to have its own race of underworld beings, called the Nradas, whose subterranean home can be accessed from secret tunnels in North Yorkshire. The legend of the Nradas first surfaced in the book *Beneath Your Very Boots*, written in 1889 by the author Charles Cutcliffe-Hyne. The book was ostensibly a novel, but a contemporary writer actually entered the cave system mentioned by Cutcliffe-Hyne, and subsequently had some very strange experiences which led him to believe that the story was very much based on fact.

2. Good, Timothy, *Alien Base* (Arrow Books, 1999)

OUT-OF-PLACE ARTEFACTS

It seems that, back in the 1950s, three miners from Whitburn Colliery found some strange artefacts buried in the coal face, and – smelling a good story – I decided to investigate.

I actually had a relative who worked at Whitburn Colliery until its closure in 1968, so I decided to pop and see him to find out what personal recollections he had of the incident, if any. Did he remember anything strange being discovered? Well, he did have a vague recollection of 'something' being found, but he wasn't there at the time and couldn't remember what it may have been. Next I talked to some of my relative's colleagues who had worked at Whitburn and other collieries in the area. Two said that they had no recollection of any strange finds at all, but another said he did remember something being found and that he thought it may have been shards of ancient, broken pottery.

At this juncture I seemed to hit a dead end in my research, but then I happened to mention the incident to my good friend Ivor Muncey who has periodically fed me with good stories. Ivor's neighbour was a miner at Westoe Colliery and he remembers some sort of tunnel being found whilst the coal face was being worked. Ivor had heard that the tunnel was definitely man-made and seemed to be of ancient origin. Extraordinarily, it was apparently discovered several miles out under the North Sea. I spoke to Ivor's neighbour and he confirmed that the tunnel was indeed 'strange', but tended towards the idea that it was of natural origin. I quickly concluded that what I had here were two separate stories: one concerning mysterious artefacts being discovered at Whitburn and a second involving a strange tunnel being uncovered in a seam at Westoe. More and more curious, I thought.

My next step was to speak to Barry Clark, a deputy overman at Westoe until his retirement in 1979. Barry worked on the No.2 Sea Winnings Drift and told me that eventually the undersea seams extended for 8 miles. Barry remembered nothing about any strange discoveries. 'It was virgin ground,' he told me. 'No one had been there before. If there had been any strange things found they would have been the talk of the place.' But at this point I remembered what Jonty, another retired miner, had told me over a pint in the Stag's Head in Fowler Street: 'I don't think we would have been encouraged to speak about anything like that. Just think of the money that would be lost if they'd had to close down part of the face while investigations were made. Any funny discoveries and I'm sure we'd have been told to keep our trap shut.' Well, quite.

My next port of call was the Coal Authority in Mansfield. As British Coal no longer existed, would they perhaps have a Department of Mysterious Artefacts and Strange Tunnels which could help me? Alas, no, and once again my investigation stalled. During my research I found that opinions were polarised regarding these strange goings on. Some miners felt – to put it bluntly – that it was all a load of cobblers. Others, however, were sure that something had indeed been found many miles out under the North Sea. What was it? A natural cavern or fissure? The remains of some long-forgotten civilisation which had been buried for all eternity in a giant cataclysm? Who knows? Maybe – just maybe – Atlantis doesn't lie buried 'beyond the pillars of Hercules' as the ancient Greeks would have us believe. Maybe it lies at the end of a now-flooded shaft leading from the old Westoe pit.

CHAPTER 21

A MISCELLANY OF WEIRD OCCURRENCES

For over four decades I've journeyed through the twilit landscape of the supernatural, written over 1,000 newspaper, magazine and Internet articles and columns as well as a number of books. I've investigated hauntings, poltergeist infestations, UFO sightings, alien abductions and sightings of mystery animals both here and abroad. Despite the breadth and depth of my experience, however, I still regularly come across tales of the unknown that are difficult to classify. Some years ago I became rather frustrated at this and invented a special category to cope with supernatural tales which, well, don't have a category. I now refer to them as RAP stories, 'RAP' standing for Random Anomalous Phenomena. Below are some of the truly weird accounts I've covered in my 'WraithScape' column over the years. Some are quirky, some frightening and others will just leave you speechless.

Some years ago I told readers of my column about the strange phenomenon of 'ooparts', a contrived word which stands for 'out of place artefacts'. Quite simply, ooparts are objects that turn up in places where they really have no right to be. Recently, a reader from Houghton Le Spring gave me a wonderful example, which has puzzled him for years.

The reader, who wishes to remain anonymous, recalled a tale that his grandmother recited to him as a child. If true, then it must rate as one of the strangest oopart stories ever to get into print. Our reader's grandmother – we'll call her Freda – married in 1954 and went to live in Seaham Harbour. At the wedding her husband slipped a gold ring on her finger as they lovingly exchanged vows. To the casual observer the ring appeared to be a plain, gold band. On the under-surface, however, it bore a touching inscription: 'LOVE IS FOREVER'. Two months after they married, the happy couple took a stroll along the coast, hand-in-hand. Freda filled her pockets with seashells for a nephew, sucking in the fresh, salty air. After half an hour, or so, they headed home. That evening Freda noticed that her wedding ring was missing.

Sadly, Freda's husband died in 1972 after a short illness, leaving her with a host of happy memories. Nevertheless, they were tinged with sadness. Her most treasured keepsake would have been her wedding ring, but that too was now just a memory. Two months after being widowed, Freda went shopping. Her last port of call was a fishmonger's, where she purchased some cod. On arriving home she took a large knife and proceeded to gut the fish, and readers will probably guess what happened next. As Freda pulled back the glistening white flesh, she noticed something gleaming in the fish's abdomen. To her utter amazement she discovered that what she was looking at was her long-lost wedding ring.

I really want to believe this story, but there is a problem with it. I know of at least two almost identical tales which are in currency in other parts of the country, and suspect that most – or even all – of them are simply 'FOAF' tales. 'FOAF' stands for 'friend of a friend', because that's whom such tales always seem to refer to. 'I have this friend, and she had a friend, and you'll never believe what happened to her...' – you know how it goes.

Who knows, maybe Freda's strange experience really did happen after all. Perhaps the other stories are just spin-offs or pale imitations. Maybe, all those years ago, Seaham Harbour truly generated an urban legend of extraordinary character. How did Freda's ring get inside the fish? What power dictated that Freda should then buy that fish and retrieve her treasured wedding ring? Answers on a postcard please.

THE SPOOKY REMOTE CONTROL

A reader wrote to me back in 1998 about a strange experience that puzzled her and wondered if I could shed any light on the matter.

Whilst sitting at home watching TV, the lady in question tried to change channels using her remote control. It wouldn't work, and after several attempts she decided to alter the channel manually using the button on the TV. Irritatingly, the manual button wouldn't work either and she made a mental note to ring the repair man in the morning. Not being particularly interested in the only programme available to her, she decided to turn the TV off, except that the off button refused to work as well! The lady was, in her own words, 'absolutely fed up' by this point and decided to switch the TV off at the mains socket. By this time, however, the programme currently on TV had ended and the next one was just about to start.

As she was about to turn the TV off at the wall, she noticed that the programme just beginning was a film which she had been waiting for years to come on TV as she had always wanted to video it. Quickly she grabbed her video remote control and pressed the record button. Suddenly, she was glad that she hadn't been able to change channels, for if she had she would undoubtedly have missed a film which she had been longing to see.

Coincidence? You be the judge.

FISH FROM HEAVEN

Back in February 2002, the papers carried an intriguing article about a mysterious rock that crashed into the garden of Linda and David Burton, of Fellgate in Jarrow.

One minute Linda and David were safely ensconced in the Land of Nod, the next minute – at 2.30am to be precise – they were awoken by an almighty bang and could have been excused for thinking that the sky had fallen in. Actually, it had in a sense. On further examination they found that a tennis ball-sized lump of rock had hurtled through the heavens before punching a hole through three stacked-up garden chairs outside. Damage to the garden furniture apart, the Burtons were lucky enough to have been the recipients of a meteorite.

It's a funny old life. A galactic traveller that has whizzed around the galaxy for squillions of years finally decides to call it a day. Where does it plan on retiring to? South Tyneside. This meteorite obviously has taste, and knows that we Geordies are

A couple from Fellgate were shocked when a meteorite fell from the sky and landed in their back garden. (Artistic representation)

good company. Seriously though, the fact is that mysterious objects falling from the skies are not that uncommon. The Burtons were obviously mystified by their find, but I wonder how they would have felt if they'd been living in Canon Cocklin Street in Hendon, Sunderland, in 1918.

Picture the scene. One minute you're standing chatting to your neighbour about the price of coal, the next you're wondering why a sand eel has just landed on your head. And not just one sand eel, mind you, but dozens of 'em, in fact, bouncing all over the pavement. From the end of Ashby Street round the corner into Canon Cocklin Street, the area started to look (and smell) like a stall in Billingsgate Market.

Actually, fish falling from the sky is a mysterious phenomenon which occurs all over the world, although nobody knows why. There are theories, of course. The most popular explanation is that the fish are sucked out of the water by some sort of whirlwind which carries them for miles before depositing them somewhere else. Sounds plausible, but it isn't. The first problem is that fish-falls only ever involve one species. Investigators never – to my knowledge – find different species together, and neither do they ever find seaweed, sand, pebbles nor any other detritus nearby. Ah, but don't fish of one species swim in shoals? And wouldn't it be logical, therefore, for the whirlwind to suck up fish all of one kind from one area? Well, maybe. But it wouldn't work with frogs, though, would it? Or potatoes. Or mice. Or shoes, come to that. But yes, all of these things and more have, at one time or another, mysteriously plummeted from the sky in vast quantities to the amazement of the local populace.

Not to be outdone by the folk of Sunderland, the folk of South Shields can claim their own fall of fish in the late 1890s. One day, thousands of small herring rained down from the sky and made the residents of the Mill Dam think that something fishy was definitely going on. Now all we need are the chips, salt and vinegar.

FURTHER READING

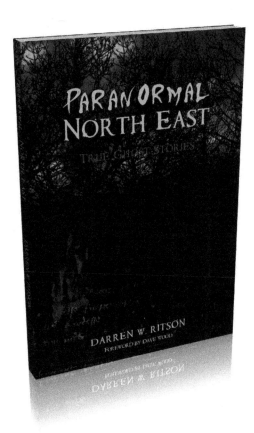

Paranormal North East
Darren W. Ritson

Price: £12.99
ISBN: 978-1-84868-196-5

Available from all good bookshops or order direct from
our website www.amberleybooks.com